HARLEY-DAVIDSON

— ⬥ — LORE — ⬥ —

ORIGINS THROUGH PANHEAD

1903 1965

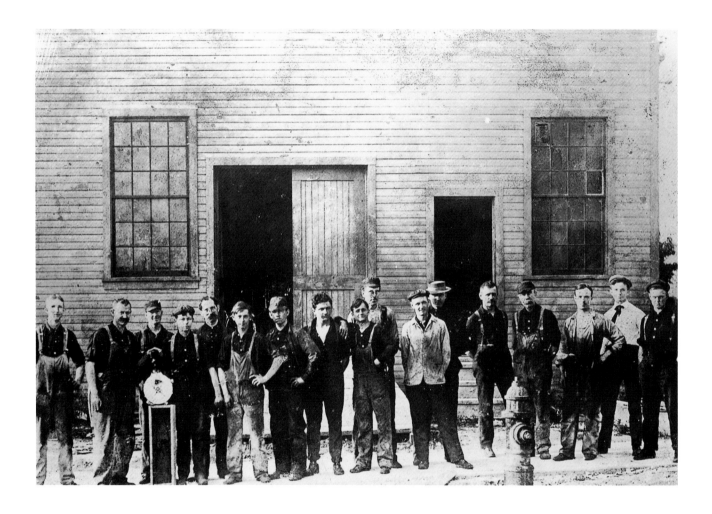

HARLEY-DAVIDSON®

— LORE —

ORIGINS THROUGH PANHEAD

1903

1965

FOREWORD: DR. MARTIN JACK ROSENBLUM, PREFACE & TEXT: HERBERT WAGNER, DESIGN: VSA PARTNERS, CHICAGO

CHRONICLE BOOKS

SAN FRANCISCO

Published by Chronicle Books
under license from Harley-Davidson
Motor Company. No part of
this book may be reproduced in
any form without written
permission from the publisher.

Library of Congress
Cataloging-in-Publication
Data available.

ISBN 0-8118-2573-6

Printed in Hong Kong.

Harley, Harley-Davidson,
Electra Glide, Sportster, Duo
Glide, Hydra Glide, Buddy Seat,
and The Enthusiast are among the
trademarks or registered
trademarks of H-D Michigan, Inc.

Super X and Indian are the trade-
marks of their respective owners.

Distributed in Canada by
Raincoast Books
8680 Cambie Street
Vancouver, British Columbia
V6P 6M9

10 9 8 7 6 5 4 3 2 1

Chronicle Books
85 Second Street
San Francisco, CA 94105
www.chroniclebooks.com

Designed by: Dana Arnett,
Ken Fox, and Michael Petersen
of VSA Partners, Chicago

Special thanks: Tom Bolfert,
Dr. Martin Jack Rosenblum,
Bill Jackson, Scott Heaton,
Joyce Muffoletto, and Cheri
Van Den Kieboom of the
Harley-Davidson Motor Company

FOREWORD
CULTURAL
AND HISTORICAL
INTEGRITY

Dr. Martin Jack Rosenblum

HARLEY LORE IS HISTORY AND LEGEND, *heritage and vision, logos and mythos equally blended. As Harley-Davidson enjoys another renaissance in popular society— of which there have been many, the ranks of the faithful swelling each time with newfound converts—there is a delightful necessity to craft a contemporary understanding of its lore. I first experienced the Harley-Davidson "way of life" as a young man in the Midwest in the fifties. Then, the term "biker" was not yet used, nor was the term "motorcyclist;" riding folk were called "bikeriders"—a term that has aesthetic implications. A motorcyclist is just that, one who rides a two-wheeled vehicle for practicality, sport, speed, or plain fun. A bikerider can ride for those reasons, true, but the implication is that he or she really rides to be set apart, to participate in a distinct culture.*

To be a bikerider is to be a Harley person, almost by default. No other brand or marque embodies so completely and consistently the bikerider aesthetic, and it

always has. Harley-Davidson has not only succeeded in the marketplace but has become an icon. It is a global symbol for the product itself, motorcycles, and for a lifestyle, one that represents a meaningful philosophical worldview and one with an evolving and complex history. Harley-Davidson lore is the collective memory and experience of this culture, and gathering it together is, in many ways, a folk art process. The Motor Company may provide the machine, but it is the bikerider who furnishes the timeless spirit and who tends to this culture and philosophy, unwilling to let it disappear under a deluge of popular fads.

The Harley-Davidson spirit is the strength and courage that comes from devotion to personal freedoms. It is individuality. Riding a Harley is the stuff of adventure and legend, and it inspires these feelings in people. The resultant sense of identity, the merging of heritage and experience, is lived from the saddle and taken into everyday affairs. The lore of Harley-Davidson is the ride. Welcome to that ride, and more... **DR. MARTIN JACK ROSENBLUM, HARLEY-DAVIDSON HISTORIAN**

PREFACE

HARLEY LORE: VOICES FROM THE PAST

Herbert Wagner

FEW SUBJECTS ARE AS RICH IN LORE AS HARLEY-DAVIDSON. From its start in Milwaukee nearly a century ago, the Motor Company has set the pace for American motorcycling. In recent years, this influence has become so strong that both foreign and upstart American motorcycle companies have begun emulating Harley-Davidson styling and tradition, thereby hoping to acquire a sliver of Harley's legendary mystique.

But true authenticity cannot be achieved overnight. Behind Harley-Davidson's allure lies over ninety-five years of rough, sometimes discouraging roadbed. Through the years, the Harley factory has faced many competitors, both two- and four-wheeled, as well as wars, economic depression, lawsuits, bad markets, and changing tastes in transportation. During these ups and downs, Harley-Davidson has sometimes thrived and sometimes barely survived. All the images in this book are genuine Harley-Davidson Motor Company photographs; some date back over ninety years. The originals are safely stored in

Harley's official Archives on Juneau Avenue in Milwaukee. The stories behind these photos are also genuine; they were not dreamed up yesterday by some public relations firm or advertising hack.

Harley-Davidson lore has grown over the generations like branches on a family tree. Whether they are close-knit club members or lone highway wolves, all Harley enthusiasts, past and present, share common memories. In this book, readers can go back, page through the Harley-Davidson album, and hear a little family history.

For our purposes, lore can be defined as the facts, beliefs, and traditions surrounding Harley-Davidson; that is, a collection of stories that may or may not be strictly historically accurate. Take, for example, the title of this book.

Through long usage, 1903 has become accepted as the first year of Harley-Davidson's existence; however, it's been acknowledged by the factory, since 1914, that Bill Harley and Arthur Davidson began tinkering with a motorized bicycle in 1901. But the 1903 date has become a part of Harley-Davidson lore through

tradition, which has, in time, made it just as "true" as the more accurate year.

The lore you'll find in this book comes from many sources. Some information came directly from the Archives of the Harley-Davidson Motor Company.

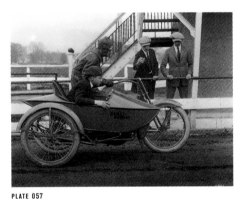

Other facts were gleaned from old sales literature or motorcycle periodicals, including Harley-Davidson's own *Enthusiast* magazine, first published in 1916. Other photos in this collection were discussed with retired Harley-Davidson employees—old timers who shared personal memories of bygone times.

In some cases there were good photos about which nothing was known—leaving me to play detective. Sometimes it was easy to match a photo with a piece of written history. Other times, all I could determine was the model of the bike—leading to discussions of its unique features

and its special place in Harley history. A few, however, remain true mysteries. For example, that pointy sidecar in the posed racing photo *(plate 057)*. Who built it? Was it used only on the race track? And the identity of those guys on an autumn ride, one holding a pumpkin *(plate 067)*. That photo appeared on the cover of the *Enthusiast* in 1924, and my hunch is that those are factory men. With their names, I might be able to tell you who they were and what they did, as I've garnered considerable knowledge over the years about employees at the Harley-Davidson factory. Without such clues, however, the voices of the past remain silent.

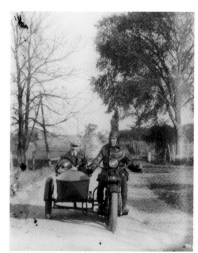

PLATE 067

Harley-Davidson's history during the first part of the century is particularly hard to document, as there is a dearth of original photos of the pre-1907 models.

This lack of photographic evidence has given rise to what H-D's official historian, Martin Jack Rosenblum, has dubbed "the era of mystery."

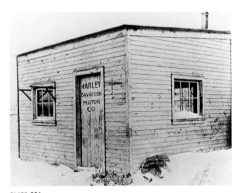

The description is apt. The number of known pre-1907 photographs of Harley-Davidson motorcycles can be counted on one hand. The oldest is a July 1905 photo that I discovered a few years ago in a grainy newspaper shot. To date, no period photo of a 1904 or earlier model has surfaced.

Other circa-1905 or earlier images include the famous "woodshed" photo *(the first plate in this book, 001)*, an illustrated ad for bare Harley motors, and a line drawing of an early (pre-1905?) bike.

The absolute earliest visual evidence of William S. Harley's interest in motorcycles dates to 1901. That July, Bill Harley drew up a set of engineering

plans *(plate 028)* for a "bicycle motor." The second sheet of this dated set survives in the possession of his descendants, and it is the oldest Harley-Davidson relic in existence.

In addition, Harley-Davidson photographs can sometimes be deceptive. As early as 1907 the Motor Company was retouching photos for advertising purposes. One example shows Walter Davidson astride a supposed 1906 model with an experimental spring fork. Historians have dated this photo—which was reportedly taken in front of the single-story wooden factory on Juneau Avenue—to the spring of 1906, but in the course of my research, I've found evidence that indicates otherwise. The photo of Walter on the bike actually dates from mid-1907 and shows a 1907 model. This photo was then

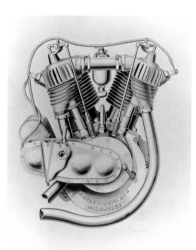

PLATE 028

superimposed upon an earlier factory shot. A small matter perhaps, but enough to throw experts off the track as to the configuration of the 1906 Harley-Davidson. Again, the so-called facts are sometimes better defined as lore.

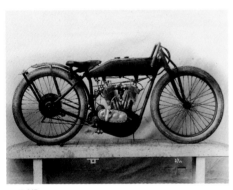

PLATE 047

After 1910, Harley-Davidson photographs literally exploded in number. That year L. C. Rosenkrans was hired as Harley's first professional photographer and a darkroom was set up on the second floor of the wood and yellow brick, two-story factory on Juneau Avenue. Ever since then, Rosenkrans and his successors have recorded every nuance of the Harley-Davidson experience. In 1912, the yellow brick factory was demolished, and Harley's photography studio was moved into the big red brick addition that replaced it. At that time Harley-Davidson claimed that theirs was the finest commercial

photography studio west of New York City. Later, Harley farmed out its photography work, most notably to Milwaukee's Pohlman studios. Over the decades, thousands of negatives have been made for Harley-Davidson, the vast majority of which have never been published.

During the first two-thirds of the twentieth century, American motorcycling went through great changes. The bikes went from spindly, razor-strap jobs to big, heavy roadburners. Riding apparel evolved just as dramatically. And as society changed, even the way that motorcycles were used and perceived was transformed.

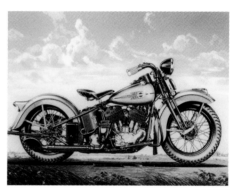

PLATE 088

But one thing has remained constant, even up to the present day: the love that generations of riders have felt for the world's oldest and greatest motorcycle, the Harley-Davidson. **HERBERT WAGNER, AUTHOR/HISTORIAN**

1903-1935

ORIGINS

BUILDING FOR GREATNESS—
THE FOUNDERS' ERA

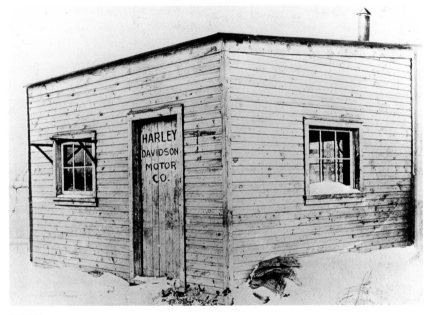

PLATE 001

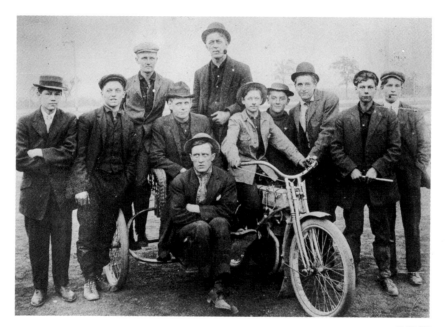

PLATE 002

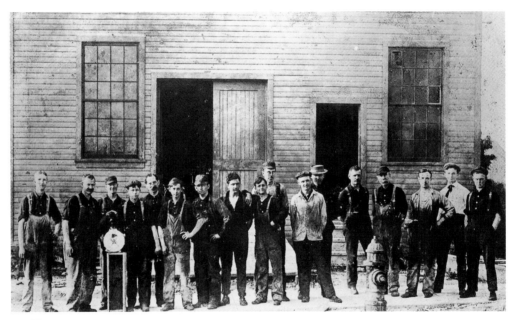

PLATE 003

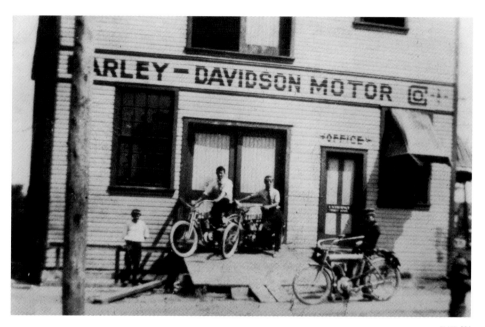

PLATE 004

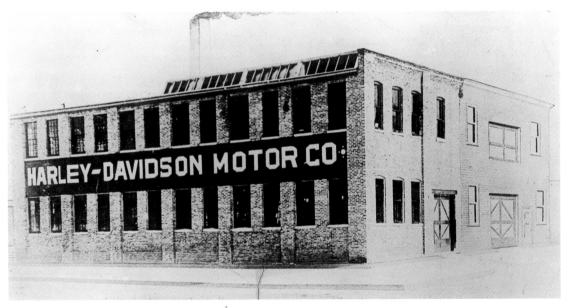

PLATE 005

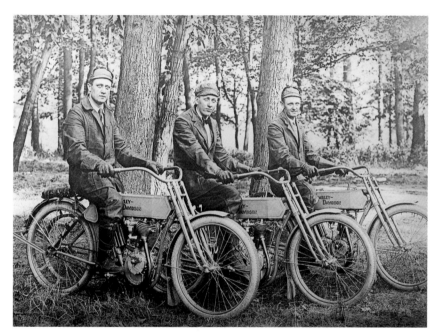

PLATE 006

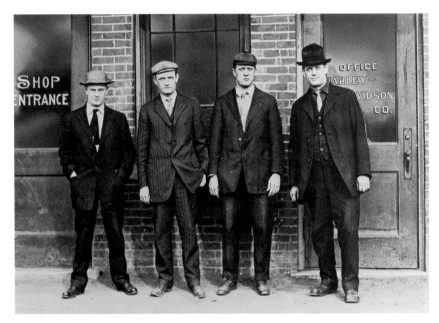

PLATE 007

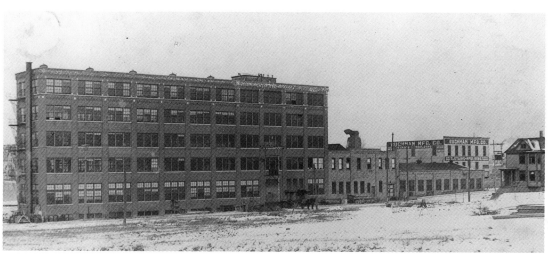

PLATE 008

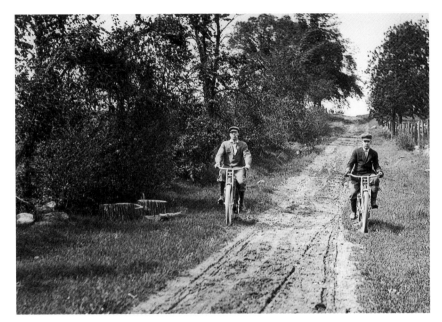

PLATE 009

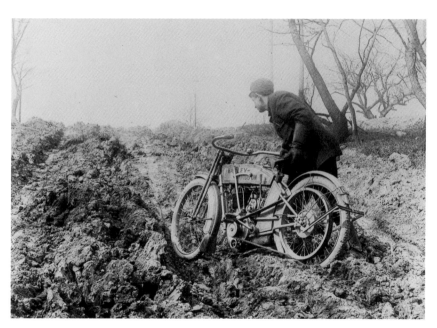

PLATE 010

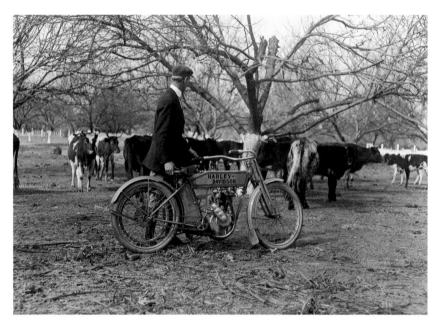

PLATE 011

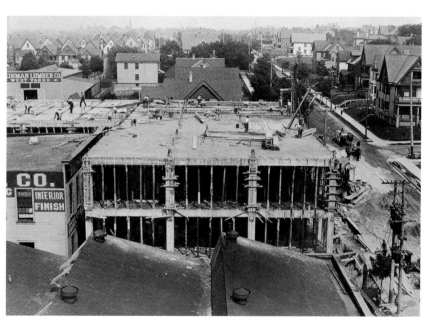

PLATE 012

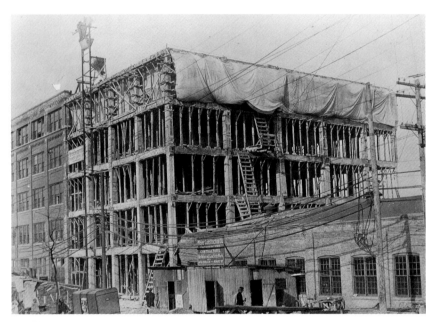

PLATE 013

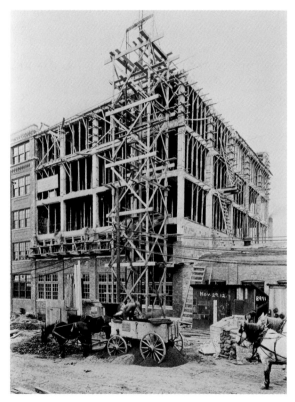

PLATE 014

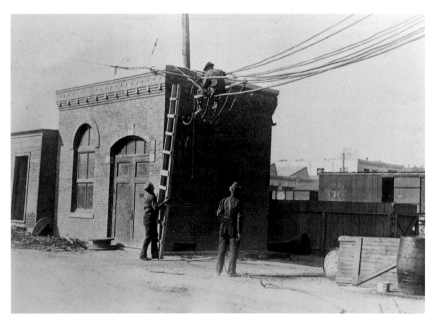

PLATE 015

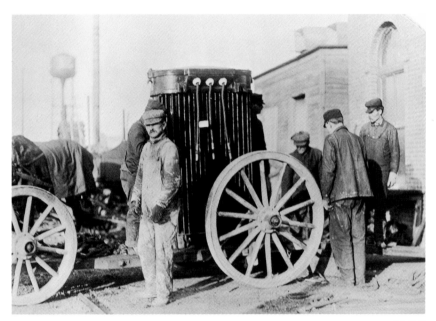

PLATE 016

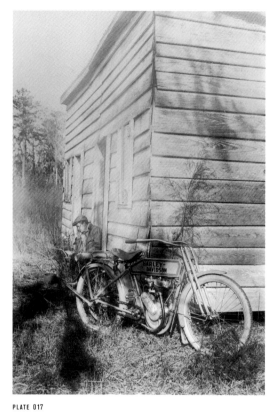

PLATE 017

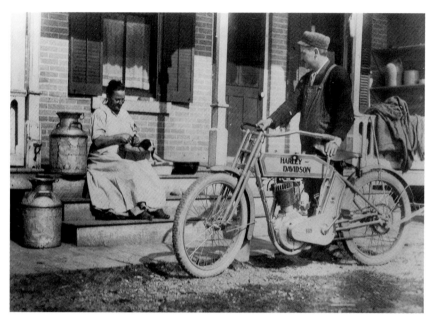

PLATE 018

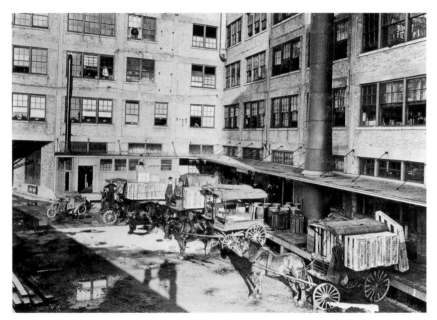

PLATE 019

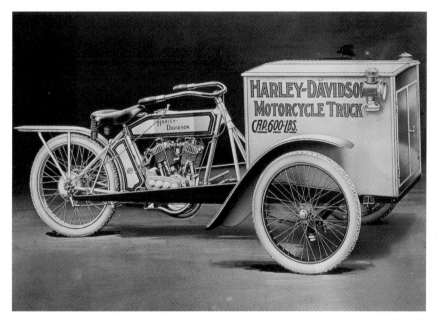

PLATE 020

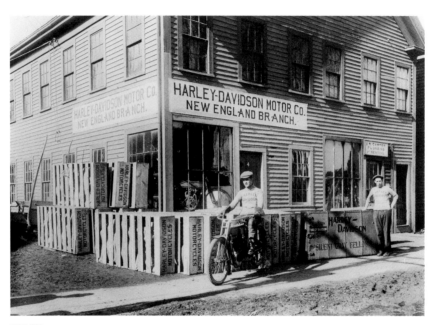

PLATE 021

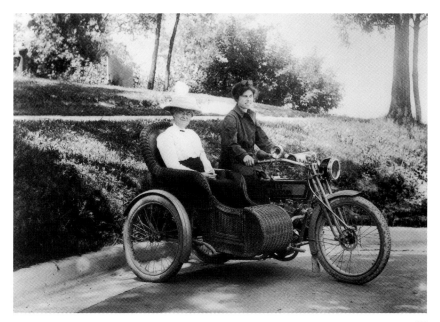

PLATE 022

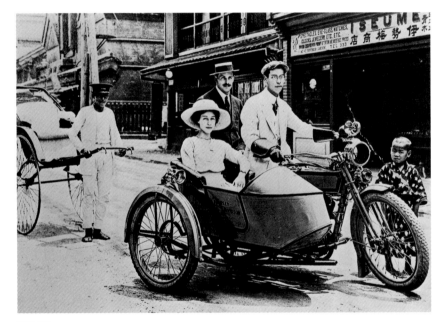

PLATE 023

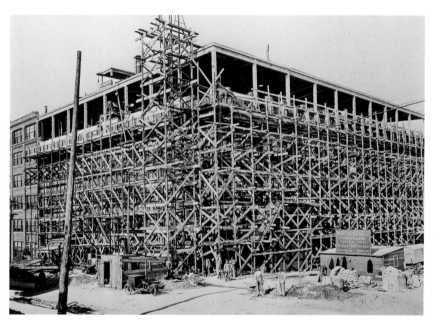

PLATE 024

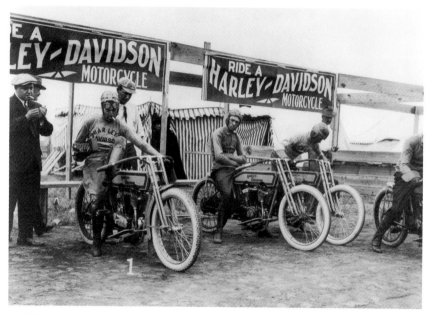

PLATE 025

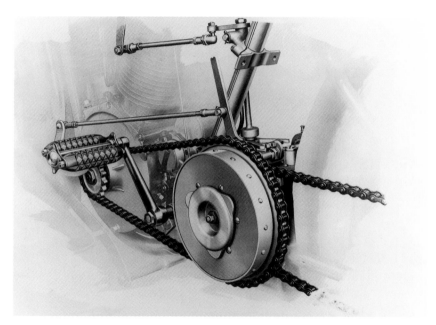

PLATE 026

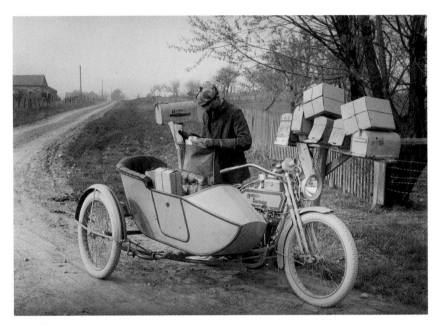

PLATE 027

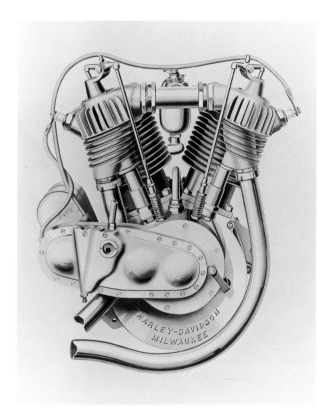

PLATE 028

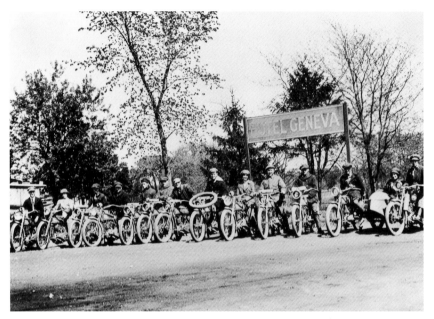

PLATE 029

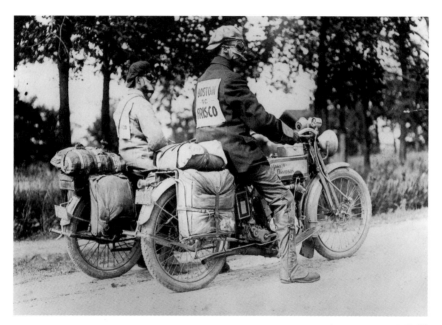

PLATE 030

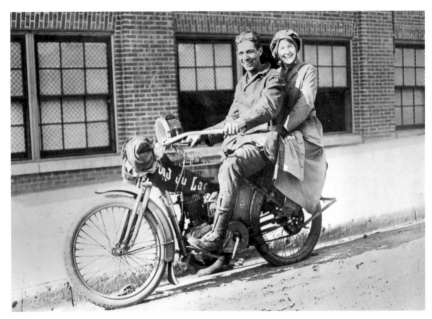

PLATE 031

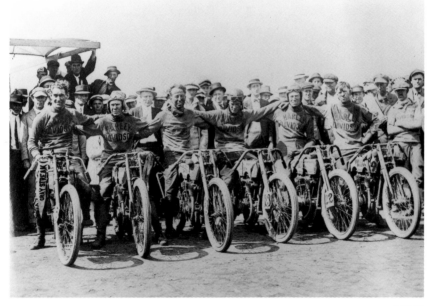

PLATE 032

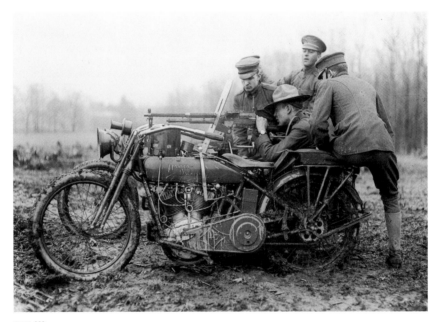

PLATE 033

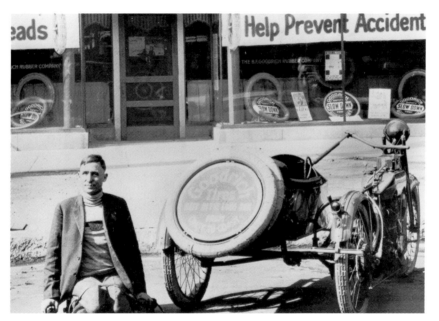

PLATE 034

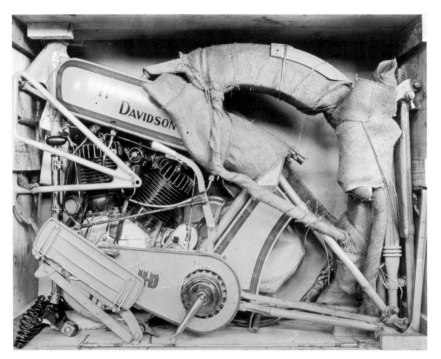

PLATE 035

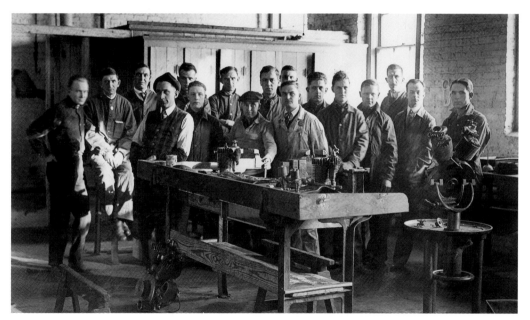

PLATE 036

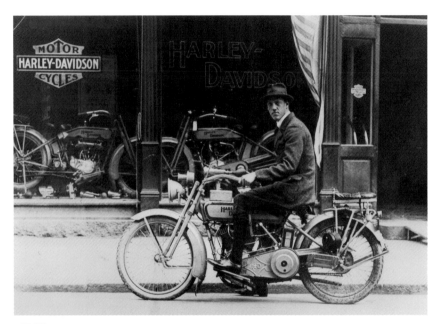

PLATE 037

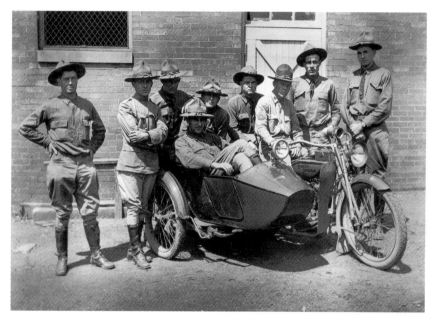

PLATE 038

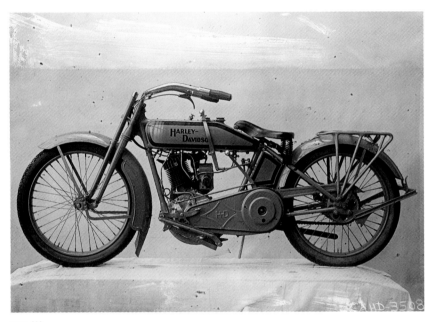

PLATE 039

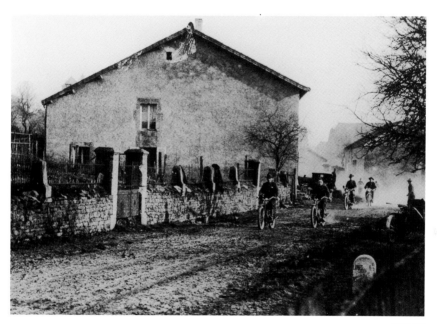

PLATE 040

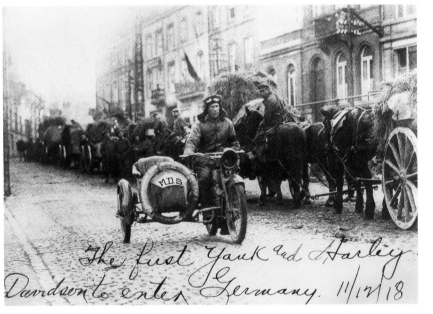

PLATE 041

PLATE 042

PLATE 043

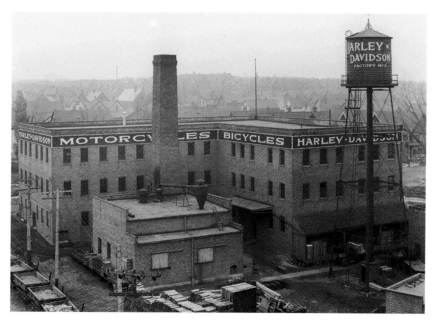

PLATE 044

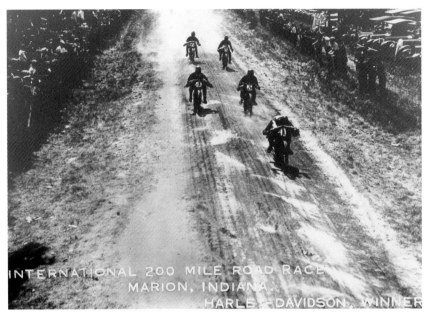

PLATE 045

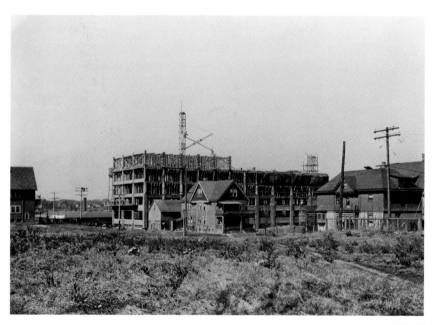

PLATE 046

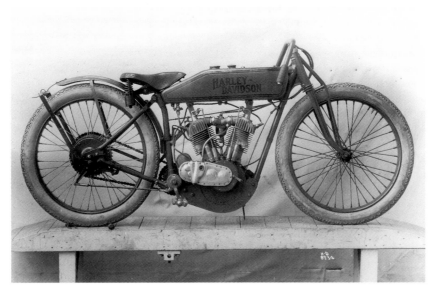

PLATE 047

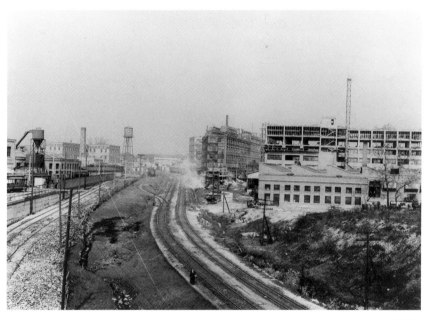

PLATE 048

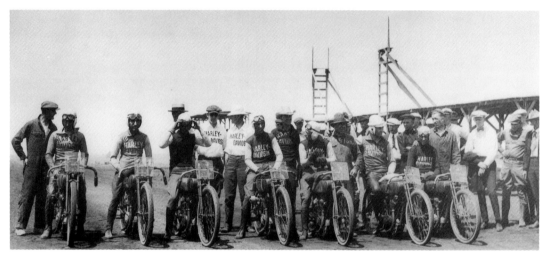

PLATE 049

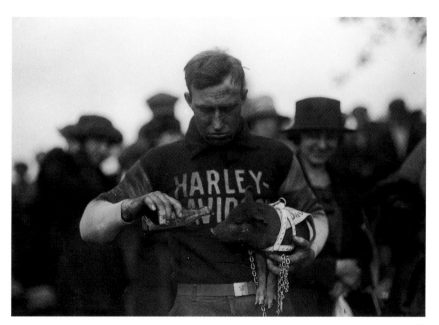

PLATE 050

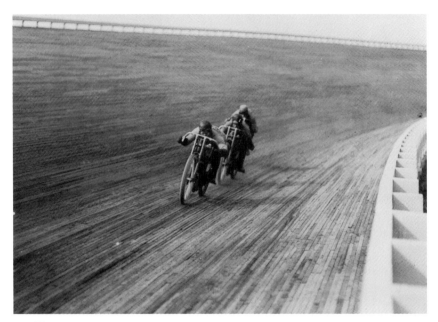

PLATE 051

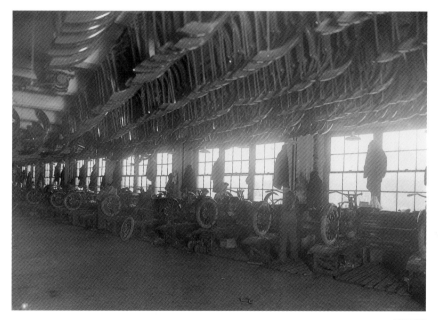

PLATE 052

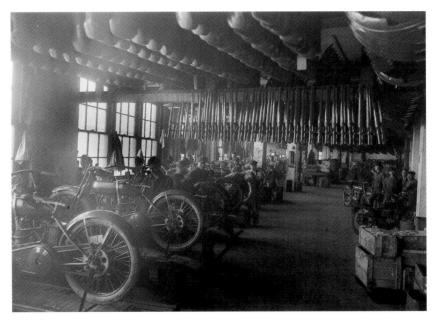

PLATE 053

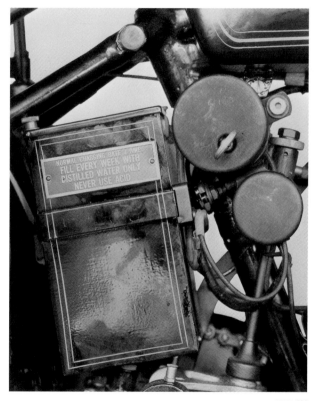

NORMAL CHARGING RATE 3 AMPS
FILL EVERY WEEK WITH
DISTILLED WATER ONLY
NEVER USE ACID

PLATE 054

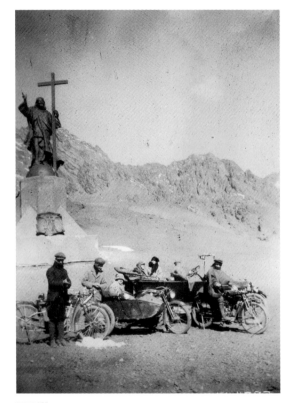

PLATE 055

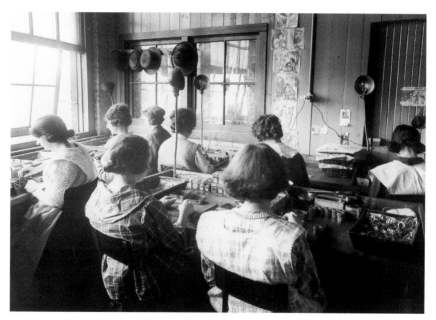

PLATE 056

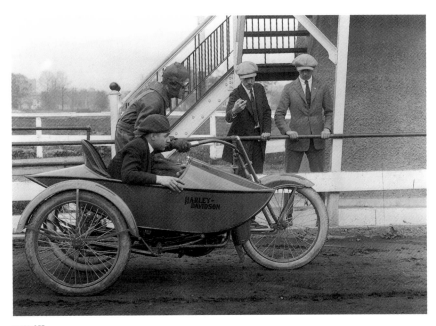

PLATE 057

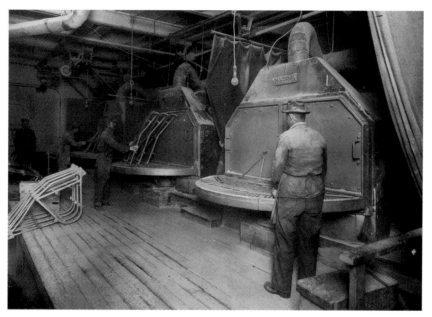

PLATE 058

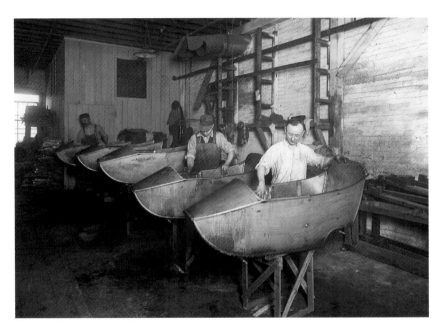

PLATE 059

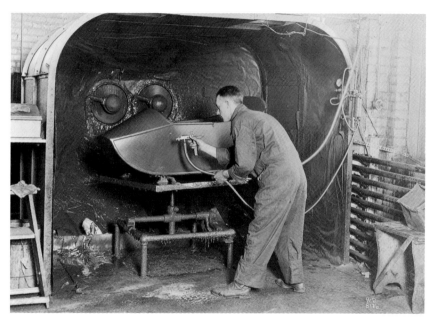

PLATE 060

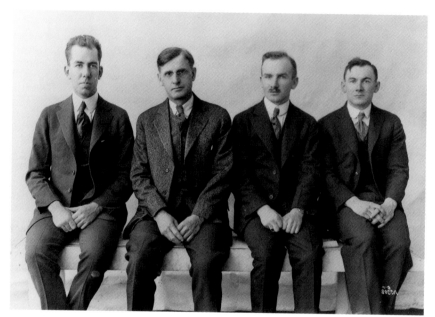

PLATE 061

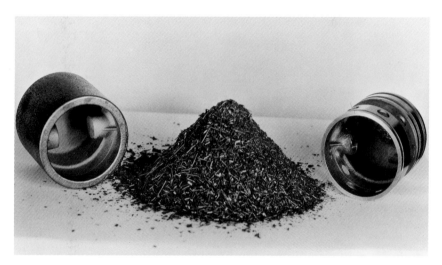

PLATE 062

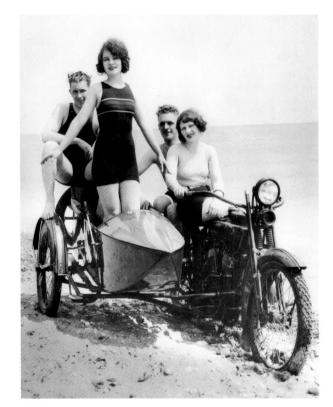

PLATE 063

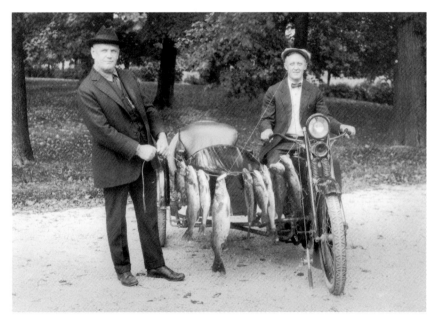

PLATE 064

PLATE 065

PLATE 066

PLATE 067

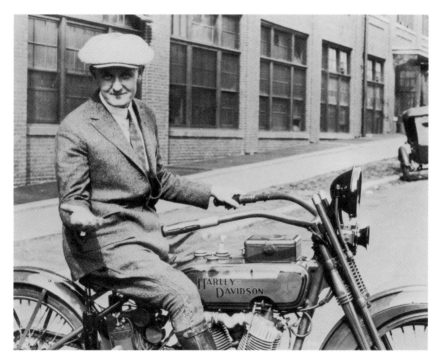

PLATE 068

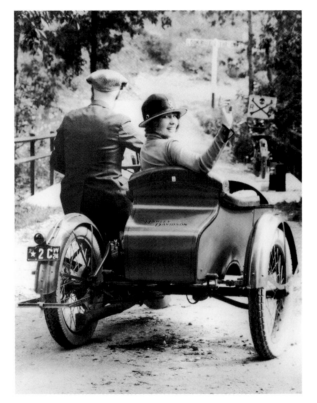

PLATE 069

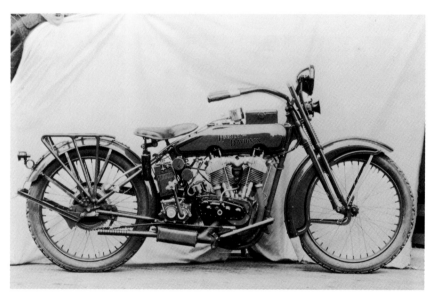

PLATE 070

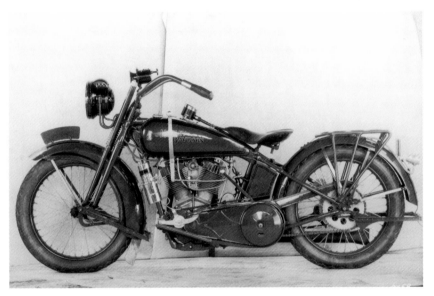

PLATE 071

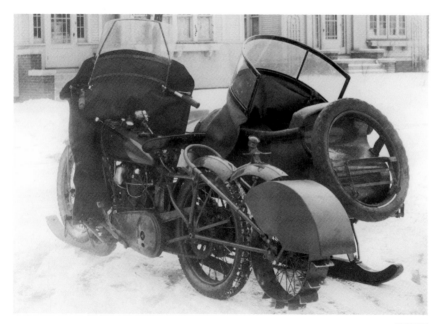

PLATE 072

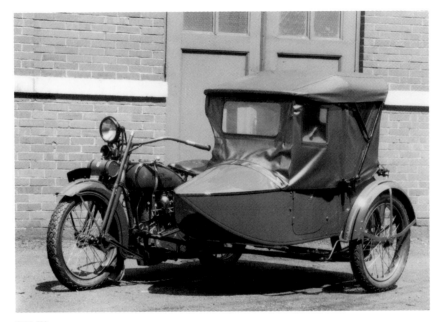

PLATE 073

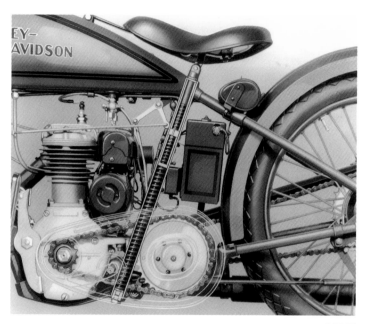

PLATE 074

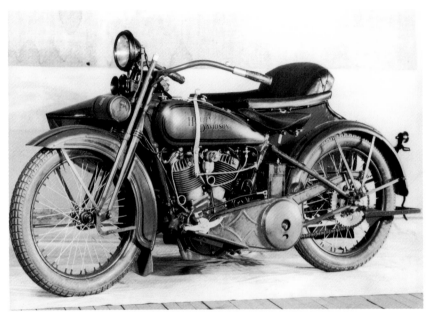

PLATE 075

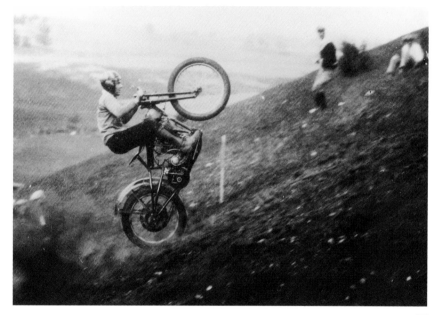

PLATE 076

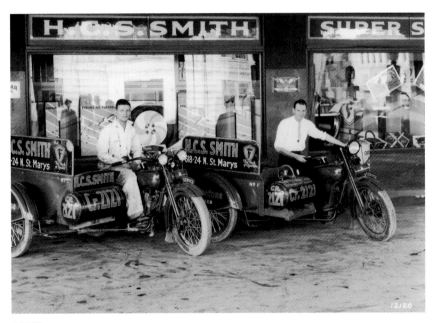

PLATE 077

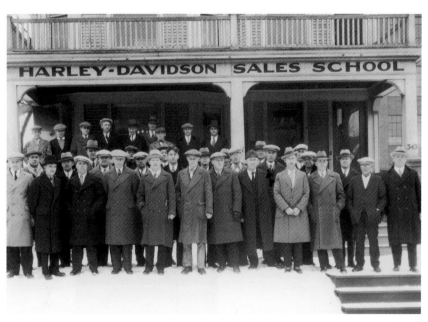

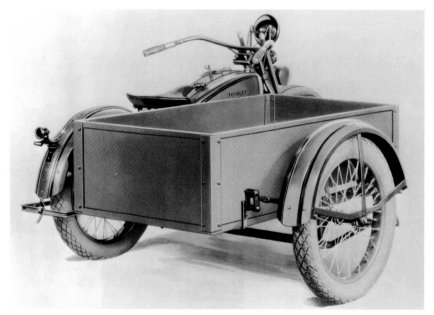

PLATE 079

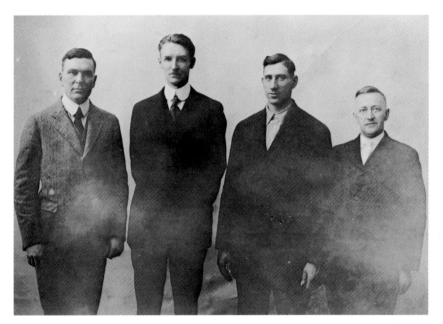

PLATE 080

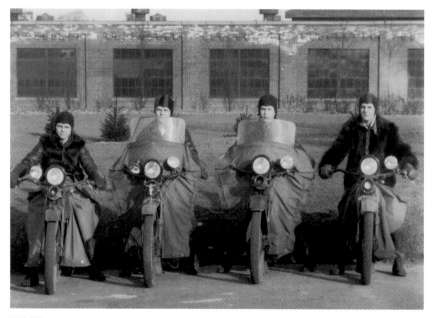

PLATE 081

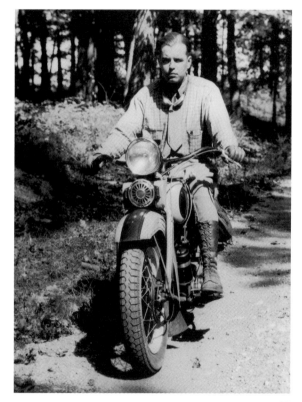

PLATE 082

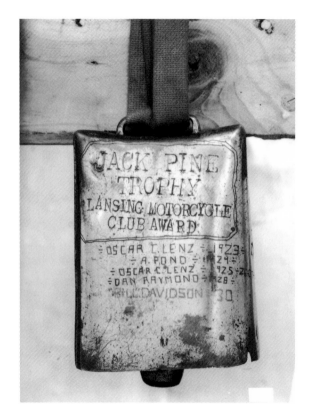

PLATE 083

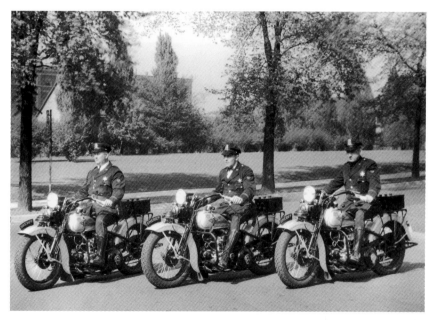

PLATE 084

1936-1947
KNUCKLEHEAD

The Classic Harley Look—
The Knucklehead Era

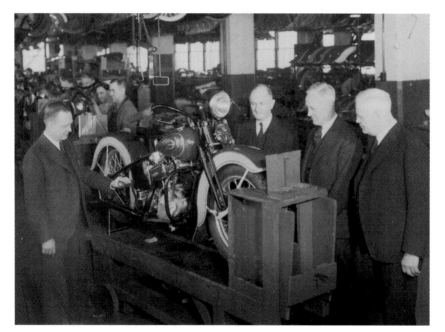

PLATE 085

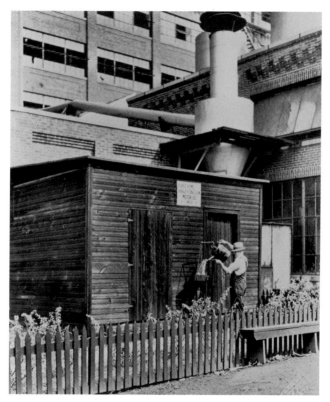

PLATE 086

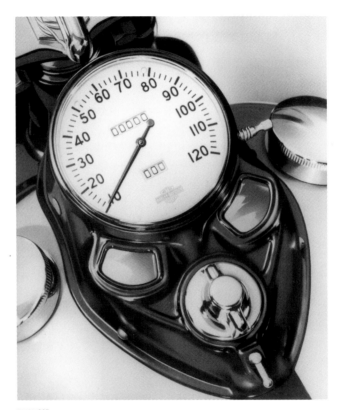

PLATE 087

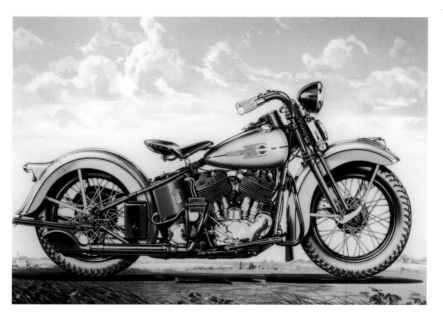

PLATE 088

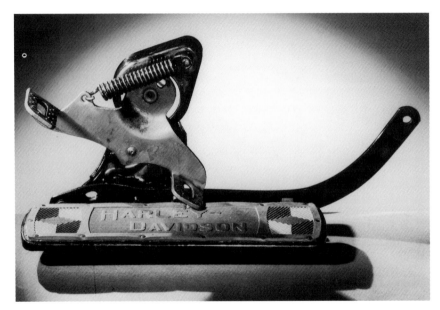

PLATE 089

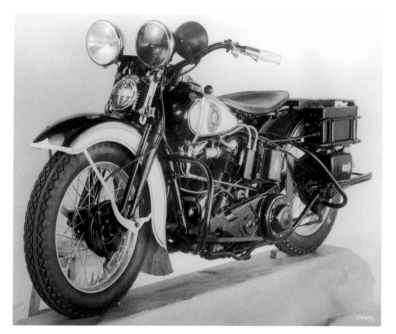

PLATE 090

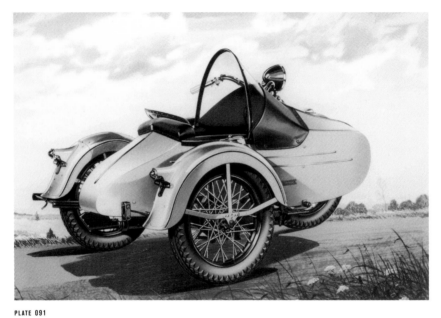

PLATE 091

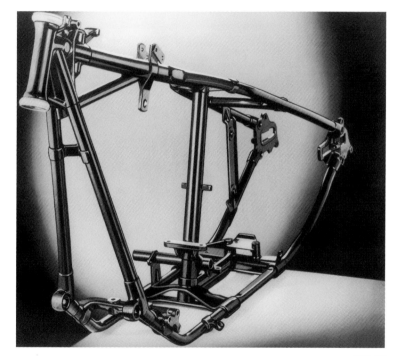

PLATE 092

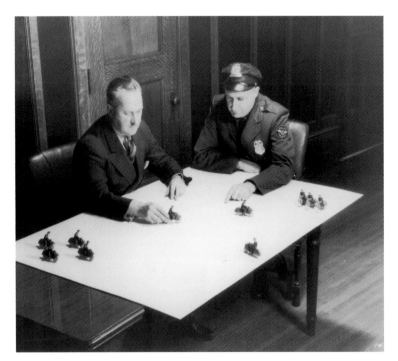

PLATE 093

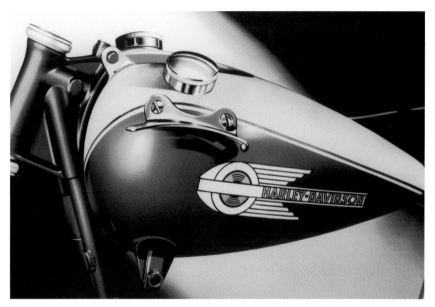

PLATE 094

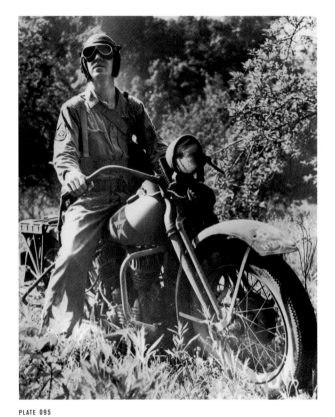

PLATE 095

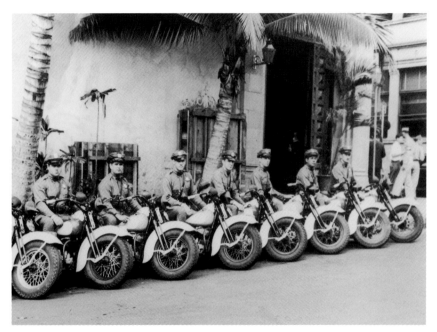

PLATE 096

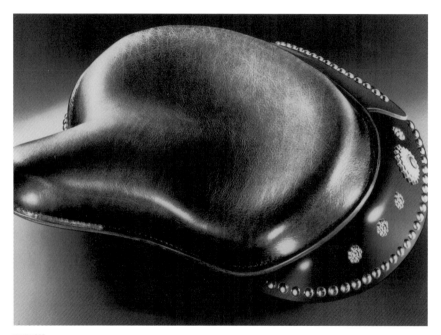

PLATE 097

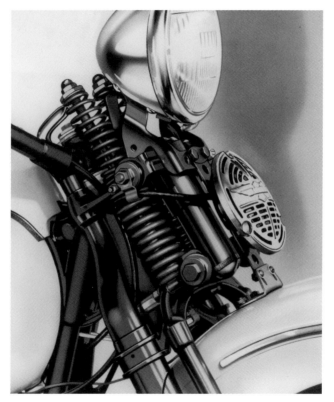

PLATE 098

1948-1965

PANHEAD

Post-War Changes—
The Panhead Era

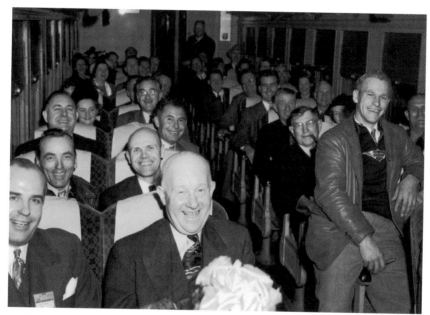

PLATE 099

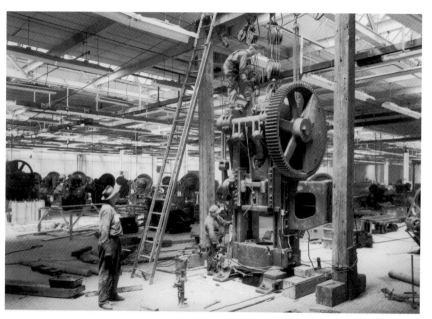

PLATE 100

PLATE 101

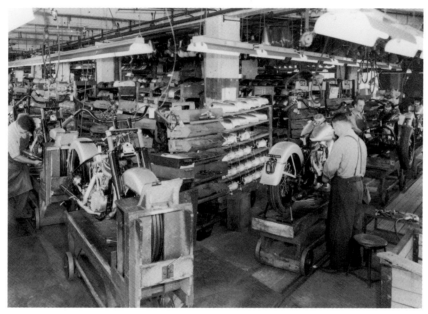

PLATE 102

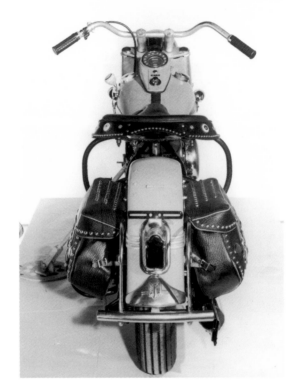

PLATE 103

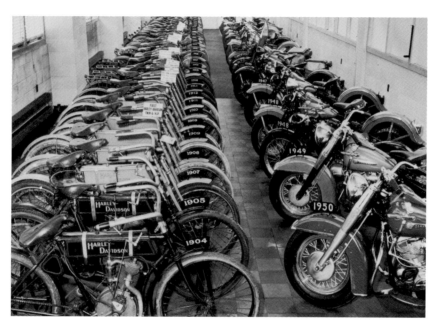

PLATE 104

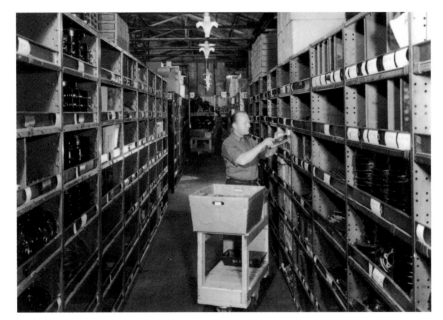

PLATE 105

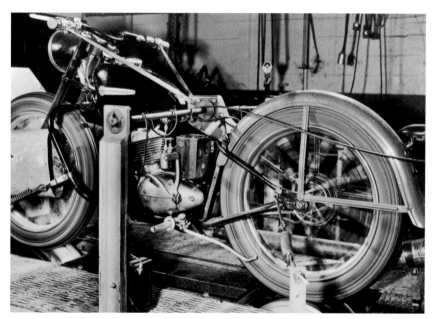

PLATE 106

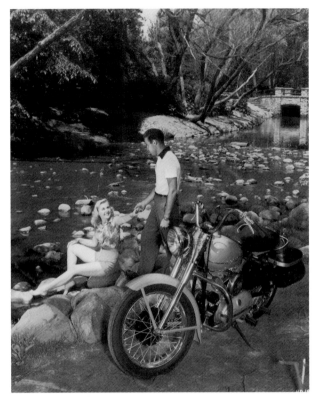

PLATE 107

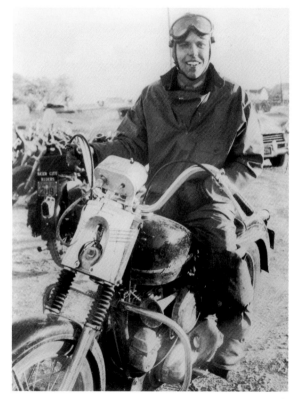

PLATE 108

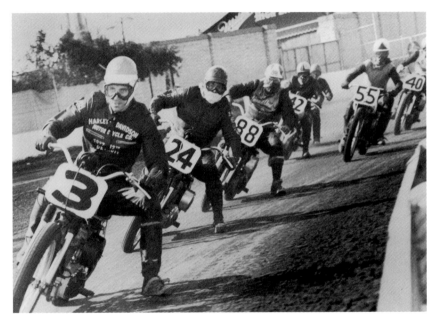

PLATE 109

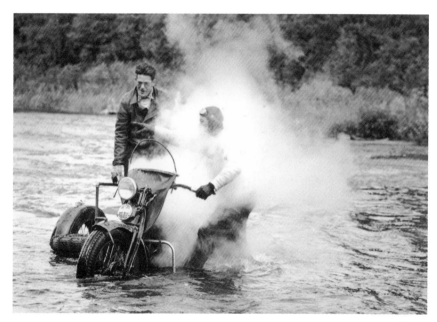

PLATE 110

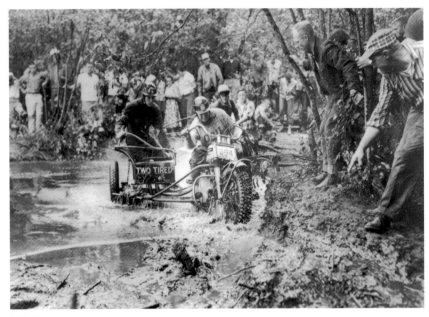

PLATE 111

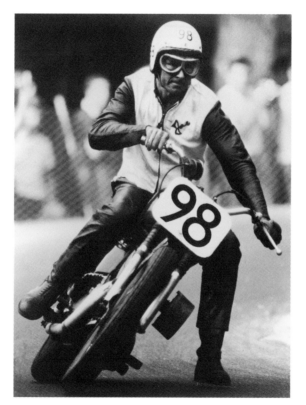

PLATE 112

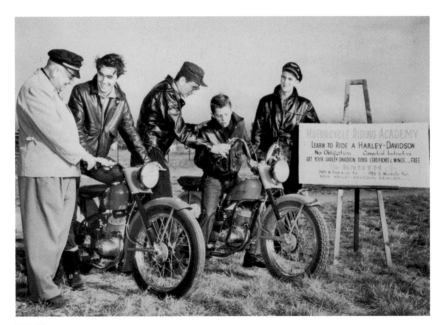

PLATE 113

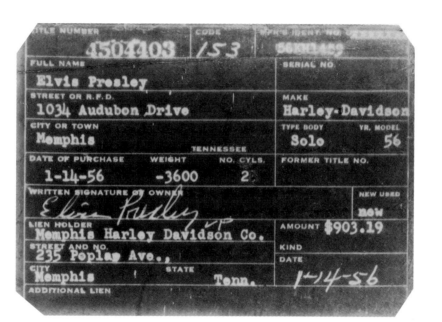

TITLE NUMBER		CODE		VEH'S IDENT. NO.	
4504403		153		56KH1459	
FULL NAME				SERIAL NO.	
Elvis Presley					
STREET OR R.F.D.				MAKE	
1034 Audubon Drive				Harley-Davidson	
CITY OR TOWN				TYPE BODY	YR. MODEL
Memphis		TENNESSEE		Solo	56
DATE OF PURCHASE	WEIGHT	NO. CYLS.		FORMER TITLE NO.	
1-14-56	-3600	2			
WRITTEN SIGNATURE OF OWNER					NEW USED
Elvis Presley					new
LIEN HOLDER				AMOUNT	$903.19
Memphis Harley Davidson Co.					
STREET AND NO.				KIND	
235 Poplar Ave.,					
CITY		STATE		DATE	
Memphis		Tenn.		1-14-56	
ADDITIONAL LIEN					

PLATE 114

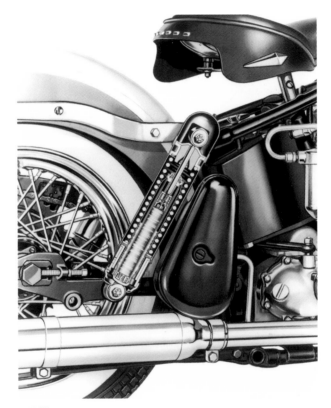

PLATE 115

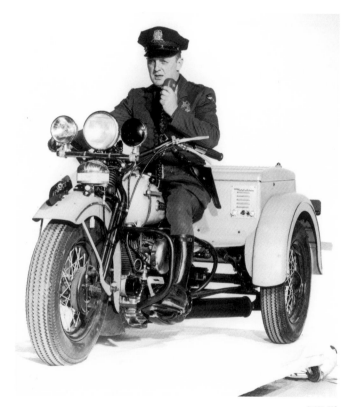

PLATE 116

PLATE 117

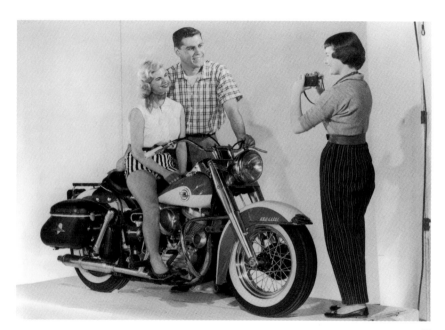

PLATE 118

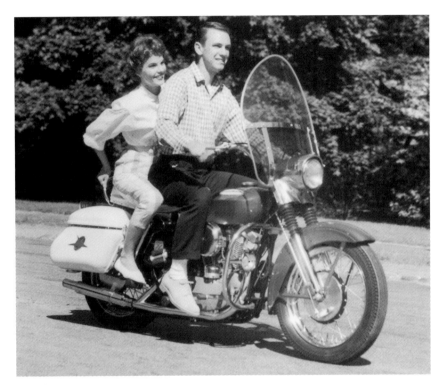

PLATE 119

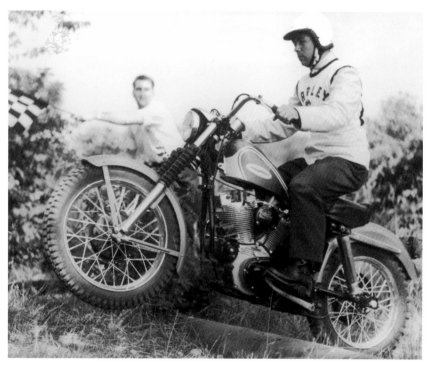

PLATE 120

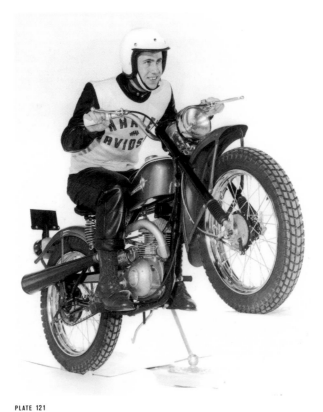

PLATE 121

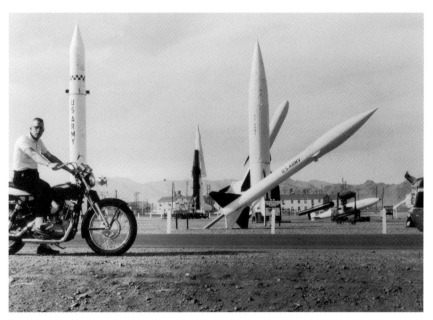

PLATE 122

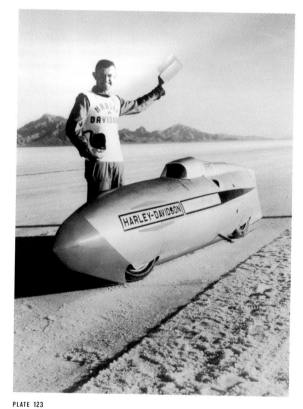

PLATE 123

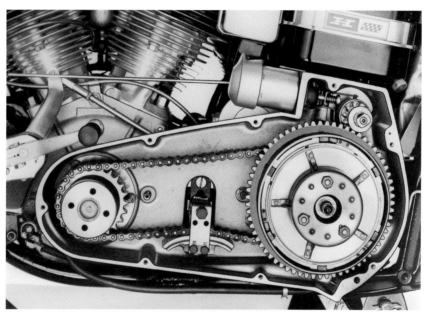

PLATE 124

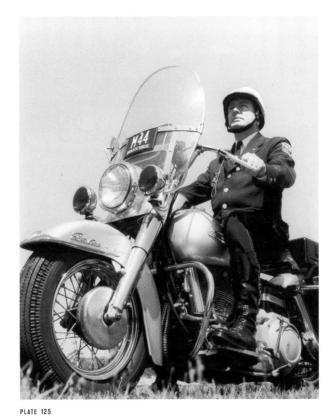

PLATE 125

T HE FOLLOWING PHOTOGRAPHS *were reproduced from originals at the Harley-Davidson Archives in Milwaukee, Wisconsin. The captions are based upon the author's primary research, advertising literature, old periodicals, and interviews with retired Harley-Davidson employees. The author would appreciate any corrections or additional information concerning these photographs and captions.*

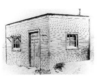

PLATE 001 (1903)
The humble first home of the Harley-Davidson Motor Company has been described as "the old shack," a "small," "humble," or "modest shed," "the first building," and a "ramshackle little shop." William C. Davidson, the father of the three Davidson brothers, constructed it around 1903. Although the woodshed was intended to serve as his own workshop, Davidson's ambitious sons and their friend William S. Harley soon took it over and assembled their first motorcycle there.

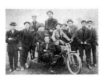

PLATE 002 (1907-8)
This photo shows Oscar Becker in the saddle, Bill Harley sitting with arms folded, Bill Davidson in the chair of the Thor-built sidecar, and Walter Davidson behind him. Edwin "Sherbie" Becker, later in charge of factory test riders, is on the far left. Next to him stands Bill Manz, who became the long-time mechanic at Bill Knuth's Milwaukee dealership. The man with the pipe is Max Kobs, in charge of early engine assembly and owner of the only 1909 Harley V-twin, registered that year for street use in Wisconsin.

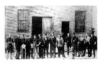

PLATE 003 (1907)
Some time after Harley-Davidson's incorporation in September 1907, Motor Company employees lined up for a picture in front of the 1906 single-story wooden factory that stood where the current Juneau Avenue offices are today. The identities of only some of the men are known. From left to right are Emil Becker (second from left), Edwin "Sherbie" Becker (third), Albert Becker (eighth), Max Kobs (tenth), Walter Davidson (eleventh), Frank Ollerman (twelfth), William A. Davidson (thirteenth), William Fisher (fourteenth), Henry Melk (fifteenth), and Arthur Davidson (far right). Bill Harley was absent due to his job at the Wisconsin Bridge and Iron Works.

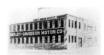

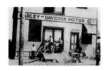

PLATE 004 (MID-1908)

By mid-1908, the little Harley factory on Juneau Avenue had received a second story along with a general sprucing up of the premises. The fellow sitting on the motorcycle at the top of the ramp looks like Bill Harley, who had graduated from the University of Wisconsin the previous June. The bike on the lower right appears to have a Harley engine, fork, and frame, but the tank, handlebar, and fenders are unlike any early Harley known.

PLATE 005 (1908)

In late 1908 the Harley factory on Juneau Avenue (formerly Chestnut Street) received a brick addition to its west side. In 1909 a sawtooth machine shop was added on the east side and the wooden middle structure faced with cream-colored brick. Old-timers refer to this long-vanished building as "the yellow brick factory." This illustration first appeared in H-D's 1909 sales catalog.

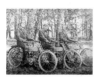

PLATE 006 (1910)

Of 125 starters, only 24 finished the 506-mile endurance run over the Pocono Mountains in 1910. Among them were these three Milwaukee riders. From left to right: H-D's chief engineer, William S. Harley; factory road tester Frank Ollerman; and company president Walter Davidson. The 1910 model shown was the last year of the "beehive" motor with horizontal cooling fins in the head area.

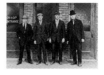

PLATE 007 (1910)

Taken in 1910 shortly after the first section of the present "red brick factory" was built on Juneau Avenue, this photo shows how the four founders of Harley-Davidson worked as a team that bridged office desk and factory floor. From left to right: Arthur Davidson, Walter Davidson, William S. Harley, and William A. Davidson.

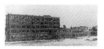

PLATE 008 (EARLY 1911)

This view across Juneau Avenue shows the rapidly growing Harley-Davidson plant in 1911. From right to left we see a private residence on 37th Street, the Buchman Manufacturing Company, and H-D's sawtooth machine shop built in late 1909. The first four windows in the adjacent structure belong to the wooden two-story 1906-8 building, here seen faced with yellow brick. The next four windows are in the yellow brick addition built in late 1908. Last, we see the 1910 and 1910-11 joined sections of the new red brick factory.

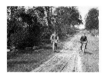

PLATE 009 (1912)
One early advantage the motorcycle had over three- and four-wheeled vehicles was its ability to avoid bad road surfaces. When necessary, motorcycles could ride the narrow shoulder or center hump, thus avoiding the deep ruts and mud that plagued early motorists...

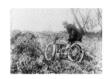

PLATE 010 (1912)
...but not always. This photo starkly illustrates one reason for the early success of the Harley-Davidson motorcycle. When the going got tough, the Harley kept going. Simple, powerful, and strong, the Milwaukee product was famous for its rugged durability in conditions we can scarcely imagine today.

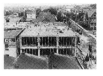

PLATE 011 (1912)
In 1912-13 Harley-Davidson made a number of photographs portraying rural life. This one from 1912 could represent either a gentleman farmer out inspecting the herd or a city slicker enjoying the countryside. The Harley logo on this magneto-equipped belt-drive single is larger than normal, as is sometimes seen in publicity shots.

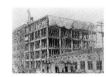

PLATE 012 (1912)
Taken from the roof of the yellow brick factory in July 1912, this photo shows the big L-shaped red brick addition going up on the corner of 37th and Juneau. Having bought the Buchman Manufacturing Company, H-D moved that building into the ell of the new structure and used it to manufacture the "Free Wheel Control." When the new factory was completed, the Buchman building was razed. At this time William A. Davidson lived in the fourth house across the street on the right. The third roof on the other side of the new factory addition is that of Arthur Davidson's home.

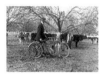

PLATE 013 (1912)
Even with the big new east building, factory space was so tight that in late 1912 a second five-story addition was commissioned. This replaced the 1906-8 section of the yellow brick factory. Here it is shown in November as Arnold Meyer's concrete workers finish the top floor. Tarpaulins and heaters were necessary to keep the fresh concrete from freezing. For an early finish the Meyer Company was awarded an $1,800 bonus from Walter Davidson.

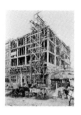

PLATE 014 (1912)
Ten days after the concrete work was finished, Edward Steigerwald's brick masons were already closing in the new addition's second floor. Experts called Harley-Davidson "crazy" for attempting to build two new additions in a single season, but machinery was humming before winter set in. It was a pace of construction the city of Milwaukee had never seen before. The Steigerwald Company still works for Harley-Davidson today, underlining H-D's "family" way of doing business.

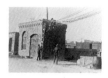

PLATE 015 (1912)
Before 1910, Harley-Davidson produced its own electric power by engine and coal gas producer plant. By 1912, Milwaukee city electricity was powering the new red brick factory. This photo shows cables being installed in the newly constructed transformer house. Today, the transformers are on display in the conference center at Juneau Avenue. The transformer house is still in use.

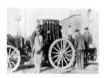

PLATE 016 (1912)
Here the new transformer is shown being delivered in late 1912. This upped the electrical capacity of the new factory from 700 to 1,000 horsepower, helping to boost production from 3,852 bikes in 1912 to 12,966 in 1913.

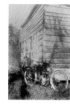

PLATE 017 (1912)
The early Harley-Davidson motorcycle was known as the "Silent Gray Fellow," but that familiar nickname was a modification of the earlier slogan "Sturdy Gray Fellow." The reason for this change is unknown. While somewhat primitive-looking to modern eyes, the 1912 Harley shown here was in fact silent, sturdy, and reliable enough to carry the rider on great outdoor adventures.

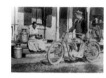

PLATE 018 (1913)
The old world German-Wisconsin farmer meets the twentieth century as Harley-Davidson promotes the motorcycle as the ploughman's friend. The 1913 chain-drive, magneto-equipped single shown here was still competitively priced at $290 at a time when the cheapest Ford "T" cost $525.

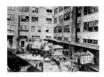

PLATE 019 (1913-14)

For years, auto and motor-cycle builders predicted the end of the horse, but it was slow in coming. This 1913 or 1914 view shows teams backed up to the north shipping dock at Juneau Avenue in the ell of the big east addition. The corridor on the left went through the building and exited on 37th Street. The outlines of this passage, now bricked up but still visible, once echoed with the sound of horses' hooves.

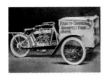

PLATE 020 (1914)

Nothing better illustrates Harley's early belief in the motorcycle's practical side than the "Motorcycle Truck" or "Forecar." Offered for three years beginning in 1913, this 61-cubic-inch powered vehicle used a standard truck tread of 56 inches. Steering was through handlebar, lever, tie rods, and steering knuckles. This 1914 Forecar is fitted with the "two-speed" rear hub. No surviving Forecar is known.

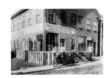

PLATE 021 (1914)

This 1914 photo shows W. J. Walker's branch dealership in Danvers, Massachusetts. Described as a Harley man from the word go, Walker gave an iron-clad money-back guarantee with every Harley he sold. "I have no desire to sell anything that I cannot back up fully," he said. From the number of new bikes in crates seen here the policy must have been successful.

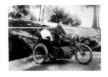

PLATE 022 (1914)

In 1914, Mrs. Rachel Foster Avery and her daughter Julia were students at the University of Wisconsin on a dairy farm tour of Europe when World War I broke out. A postcard sent by the Averys late in August of that year to Madison H-D dealer H.H. Daniels tersely stated: "Motorcycle and sidecar confiscated for war purposes." It is unknown which of the belligerents seized the machine or whether it was ever returned.

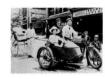

PLATE 023 (1914)

In 1914 the Milwaukee factory announced that it had shipped motorcy-cles like this "two-speed" twin with Rogers sidecar to the following countries: England, Scotland, Wales, Holland, Sweden, Denmark, Belgium, Italy, Portugal, Australia, New Zealand, Java, Sumatra, Puerto Rico, Japan, Philippine Islands, Korea, Hawaiian Islands, Russia, South and West Africa, Siam, Chile, Argentina, and Peru.

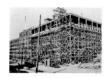

PLATE 024 (1914)

In the autumn of 1914, a sixth floor—or seventh, as Harley-Davidson bragged, counting the basement—was added to the east (1912) addition to the red brick factory. In 1922 this uppermost floor was extended west over much of the earlier 1910-12 construction. Note the Forecar motorcycle truck parked out front.

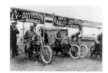

PLATE 025 (1914-15)

A letter written by Otto Walker to Milwaukee Harley dealer Louis Peterik (circa 1914–15) reveals the conditions early racers endured: "Twenty laps from the finish I got a bad kink in my neck and I simply could not hold my head up. I had to ride with my nose on the handlebars... With my head in this position I got all the oil which squirted out of Perry's ports and had to snatch off my goggles when the oil smeared them up."

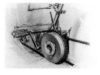

PLATE 026 (1915)

With front chain guard removed, the 1915 twin shows the classic Harley clutch and primary drive. First appearing in 1914, the "Step-Starter" allowed the rider to start the engine from either side of the bike with a single forward stroke of either pedal. In 1916 the more conventional right side "kick-starter" appeared.

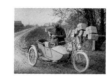

PLATE 027 (1915)

By 1915 many rural mail carriers favored the motorcycle for delivery purposes. That year the Postmaster General issued an order specifying that motorcycles for postal use must have engines of 60-cubic-inch or greater displacement and a sidecar body that would protect the mail. Milwaukee soon developed a water-tight sidecar for delivery service to replace the passenger model shown here.

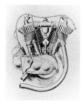

PLATE 028 (1915)

The big news about H-D's 1915 twin was its automatic mechanical oil pump located toward the rear of the gear cover. Harley was quick to explain its advantages over the old "drip feed" system. Now both over- and under-oiling of the motor was deemed "impossible" according to factory sales literature.

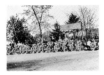

PLATE 029 (1915)
Group motorcycle riding quickly became a popular social event. Nearly every weekend, members of the Milwaukee Motorcycle Club would visit a local attraction within an easy ride of the city. Here a group of riders in 1915 is seen at Lake Geneva, a popular resort destination southwest of Milwaukee.

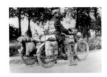

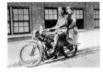

PLATES 030, 031 (1915)
After 1914, Harley-Davidson's big red brick factory became a must-see destination for travelers on their Harleys. They made Milwaukee a stop on cross-country tours, as witnessed by this pair of riders traveling between Boston and San Francisco. They also came on day visits, as shown by this smiling couple from nearby Fond du Lac.

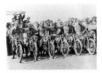

PLATE 032 (1915)
The 1915 Dodge City 300-Mile Race was Harley-Davidson's first major win in the big factory team events. Pictured from left to right in their finish order are Otto Walker (first), Harry Crandal (second), Joe Wolter (fourth), Leslie "Red" Parkhurst (fifth), Alva Stratton (sixth), and Ralph Cooper (seventh). After this date Indian's former racing dominance was smashed forever.

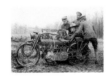

PLATE 033 (1916)
In early 1916 Harley-Davidson tested its "fighting motorcycle" at a rifle range near the Milwaukee-Racine County line. Mud clay along the route forced the removal of front fenders on both the machine gun and ammo carrier sidecars. The Wisconsin National Guard peformed the tests; they are shown here demonstrating the French Bennett-Mercer (Benét-Mercié) machine gun. The next day both machines were shipped south to take part in trouble along the Mexican border.

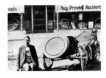

PLATE 034 (1916)
Al LeRoy of Los Angeles stopped off in Milwaukee during his second round trip of the continent in 1916. LeRoy, who lost both legs in a streetcar accident, had modified a sidecar so he could control the bike while sitting in the tub. In Arizona he picked up a rope used to hang a murderer and kept it to assist bogged down motorists along the way.

PLATE 035 (1916)
For decades, Joe Traudt
was in charge of H-D's
crating department.
He was already there in
1916 when this single-
speed twin with forward
stroke Step-Starter was
shipped. As recently as
two years earlier, Harley-
Davidsons were shipped
completely assembled,
but increased production
led H-D to use this more
economical method.

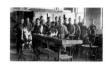

PLATE 036 (1916–17)
Harley-Davidson had
been instructing dealers
in repair work for years,
but in 1916 an official ser-
vice school was set up to
train soldiers in the main-
tenance and repair
of motorcycles. Here is
one of the first classes and
their instructor, Howard
E. "Hap" Jameson.

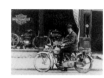

PLATE 037 (1917)
Harley's dealer in Denmark
was a strapping seven-
footer named C. Friis-
Hansen of Copenhagen.
In Milwaukee on busi-
ness, he claimed "beer
city" was his favorite
American town. Among
his customers was Prince
Axel, a member of Danish
royalty, shown here on a
1917 twin.

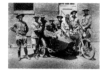

PLATE 038 (1917)
A group of World War I
army motorcycle mechanics
pose for Harley's photog-
rapher around 1917.
Instructor "Hap" Jameson
said of this group: "A
sample class which has
received the full course of
instruction... No trifles
here, all mature serious
minded men who are bent
on doing their part to
help win the war."

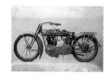

PLATE 039 (1917)
When this single-cylinder
Harley was built in 1917,
gloss olive had become
Milwaukee's standard
color. But by then most
riders wanted V-twins,
and to ease production
the factory built singles
using twin frames.
Demand was so small,
however, that singles
were dropped after 1918,
but they reappeared
briefly in 1921 and 1922
for commercial-use sales.

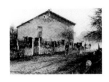

PLATE 040 (1918)
Of the 17,320 Harley and Indian motorcycles sent overseas during World War I, a mere 995 were used without sidecars. This circa 1918 photo of Harleys riding through a French village is unusual as it shows a group of the much-rarer solo mounts.

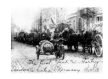

PLATE 041 (1918)
This famous photo first appeared in newspapers and magazines in 1918. It shows Chippewa Falls, Wisconsin, native Corporal Roy Holtz riding his Harley sidecar past a column of German troops shortly after the armistice was declared. A few days earlier Holtz and his captain were unintended "guests" of the fifth Bavarian division in a Belgian town. When an enemy general heard that Holtz spoke German, he was treated to several rounds of potato "schnapps" in order to loosen his tongue. On November 11 they were released and Holtz's .45 automatic pistol and sidecar were returned. The next day he and his trusty Harley crossed the German border where this photo was taken.

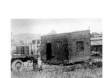

PLATE 042 (1918)
Nostalgia had become an important concept to the Harley-Davidson Motor Company by 1918 when the original woodshed factory was moved to the Juneau Avenue plant. The only visible change from the 1903 version is a door that had replaced the front window. For several decades the woodshed stood as a reminder of the Motor Company's humble origins.

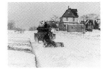

PLATE 043 (1918)
The William C. Davidson family home stood on the southwest corner of 38th Street and Highland Boulevard in Milwaukee. Looking east, we see the first backyard woodshed factory. Or do we? Actually, when this photo was taken, the original section had already been removed from the building's right side. What remains here are the 1904-6 additions. The Davidson home was razed some years ago to make way for an office building, but unfortunately no archaeological dig was conducted.

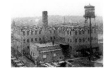

PLATE 044 (1919)
In 1916 Harley-Davidson first rented and later purchased the R. J. Preuss Bed Spring and Couch Company plant on the north side of the railroad tracks across from the main Juneau factory. Here it is shown circa 1919. Harley later disposed of the building and in more recent years bought it back again.

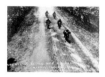

PLATE 045 (1919)
Professional racing had
been suspended during
the war years, but it came
back bigger than ever in
1919. On Labor Day
Harley-Davidson resumed
its winning streak with a
smashing victory at the
two-hundred-mile event
at Marion, Indiana, where
Milwaukee took the first
three places.

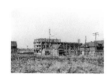

PLATE 046 (1920)
The big "south" addition
at Juneau Avenue went up
at a pace equal to earlier
construction, but without
as much fanfare. Looking
to the northwest from
Highland Boulevard in
1920, we see the new 120-
by-214-foot building
reaching skyward. Today
the Harley-Davidson
Archives are on the fourth
floor in this building.

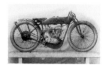

PLATE 047 (1920)
In 1915 Harley-Davidson
tried to ban twin-cylinder
motorcycles from half-
mile dirt tracks because of
rising speeds, injuries,
and deaths. Yet five years
later their standard pocket-
valve racer was a world-
record beater. This 1920
example has the "key-
stone" frame that allowed
a lower engine position
for better handling. It also
sports features long aban-
doned on road bikes, such
as a rigid "truss" front fork
and "Free Wheel Control"
clutch contained in the
sprocket-side rear hub.

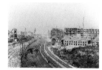

PLATE 048 (1920)
This is another shot of
the big south plant going
up in 1920. In this view,
looking east up the rail-
road tracks, the unusual
shape of the 1910-14
north building is evident.
Legend has it that old
motorcycles or parts were
used as backfill behind
a basement wall during
the original 1910 construc-
tion. Across the tracks,
note the Preuss building
owned by Harley-Davidson
during these years.

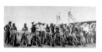

PLATE 049 (1920)
When professional
racing resumed at Dodge
City in 1920, the rivalry
between Indian and
Harley-Davidson was even
more intense than before
the war. But Milwaukee
took an early lead that
year when Jim Davis
(fourth from left) won the
three-hundred-miler over
the two-mile dirt track in
a new record of 3 hours,
40 minutes, and 4.8 sec-
onds. He collected a thou-
sand dollars for this feat.
Today Davis is a vigorous
101 years old.

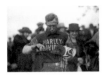

PLATE 050 (1920)
This photo shows Ray Weishaar and friend after winning the World Championship Marion International Road Race in 1920. Upon this victory a Connecticut dealer's wife baked Weishaar a cake with a miniature pig on top in honor of his lucky "piggy mascot." When the cake was devoured at the Harley factory by the racers and dealers, "grunts of satisfaction" were heard. One accepted theory holds that the "hog" nickname for H-D grew out of Weishaar's mascot and the resulting publicity.

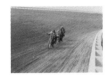

PLATE 051 (1920)
After the 1921 season Harley-Davidson withdrew factory support from professional racing. One reason was the bad public image fostered by the many injuries and deaths on the big banked board tracks of the day. Advertising manager Walter Kleimenhagen was talking about more than dollars and cents when he said to dealers in 1920, "Racing—that magic form of advertising—but land sakes how it costs."

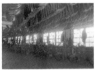

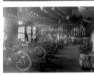

PLATES 052, 053 (1920)
Harley-Davidson took pride in the quality of its motorcycles. These photos from around 1920 show the hand-assembly methods in the Milwaukee factory. Taking a jab at the mass production methods of Henry Ford, the Harley-Davidson *Enthusiast* said in 1923, "If a modern motorcycle was built on the slap-'em-together-and-run-'em-out-on-a-belt system of factory production, you could ride one lap around the block. Then you could walk another lap around the same block with a basket and pick up the parts that fell [off] on your first time around."

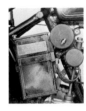

PLATE 054 (EARLY 1920s)
Proper battery maintenance was a point Harley-Davidson drove home to riders because reliable operation depended on a healthy electrical system. The round piece in front of the battery with the key on this early 1920s twin is the ignition switch. The lower part contains horn and light fuses.

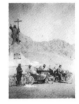

PLATE 055 (LATE 1910s–EARLY 1920s)
By 1920, H-D had dealerships around the world, and excited new owners often sent photos of Harley-Davidson motorcycles in exotic locales to the Milwaukee factory. This group of South American enthusiasts poses at the "Christ of the Andes" peace statue on the mountainous border between Argentina and Chile.

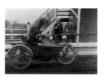

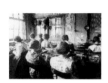

PLATE 056 (1920)
This early 1920s view inside the Juneau Avenue plant shows women workers inserting rollers into bearing races. According to the late Albert "Squibb" Henrich, who worked at H-D starting in 1924, a blind woman named Gertrude Weber inspected each roller by touch for smoothness and concentricity. This 1920 photo appeared in the Harley-Davidson *Enthusiast* magazine in 1929.

PLATE 057 (EARLY 1920s)
Sidecar racing had a strong following in the 1920s, although it never reached the popularity of solo motorcycle competition. In this posed photograph, a racing sidecar of unusual design simulates a dash across the finish line.

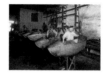

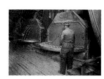

PLATE 058 (1920)
Heat played an important role in the creation of Harley-Davidson motorcycles. Complete frames were heat-treated to combine strength and flexibility. Paul Maronde, a worker in H-D's hardening department in the 1920s, said in an interview with the author, "There would be twelve frames to a car. We'd put them in for an hour at 850 degrees. That was hot work. Old Bill Davidson used to come up. He'd say, 'Paul, I really appreciate the way you're doing this work.'"

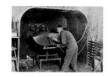

PLATE 059 (EARLY 1920s)
During the early 1920s, more motorcycles left the Milwaukee factory with sidecars than without them. The earliest sidecars were built by Thor, in Aurora, Illinois, and later by the Rogers Manufacturing Company in Chicago. After 1915, however, Harley began constructing their own, similar to the 1920 pattern shown here. Harley-Davidson alternated between these two methods over the coming decades.

PLATE 060 (EARLY 1920s)
While paint on the earliest Harley-Davidsons was applied by hand, modern spray methods were in place by 1920. Each Harley received three coats of enamel and one of varnish, all oven-baked. For several decades the "enameling department" was run by John Behrs, whose descendants claim 160 years of combined service at Harley-Davidson.

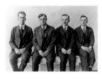

PLATE 061 (EARLY 1920s)
Employees in H-D's engineering department in the early 1920s included, from left, Arthur Herrington, a New Jersey native who came to H-D circa 1916 to work on military bikes; Bill Ottaway, who was lured away from Thor in 1913 and assisted with Milwaukee's racing program; Arthur Constantine, who worked for Harley between 1920 and 1927; and George Appel, "Desk 6" in engineering.

PLATE 062 (1922)
In 1922, Milwaukee touted the precise construction of the Harley-Davidson piston: "From the rough casting to the finished product 25 operations are necessary, five for various inspections. Approximately 75% of the metal is removed from the rough casting, insuring a perfect product from the heart of the casting, the true metal."

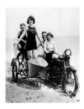

PLATE 063 (MID-1920s)
In the 1920s Harley-Davidson started using professional models for some of their publicity shots. Even then the Motor Company continued its longtime practice of using office and factory workers and local personalities during photo sessions. Unfortunately the identity of most of these persons has been lost, as Harley-Davidson rarely recorded their names.

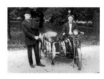

PLATE 064 (1922)
Life-long sportsmen, Bill Harley (sitting) and Bill Davidson slipped away whenever possible to hunt or fish. In 1922, they made this fine catch at Pine Lake, where Bill Davidson had a cottage. Bill Harley's place was on nearby Beaver Lake. The biggest walleye on the stringer weighed eight and one-quarter pounds.

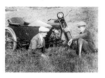

PLATE 065 (1924)
Walter Davidson and Bill Harley still rode the product they were building when this photo was used in advertising literature in 1924. Along with it ran a letter to prospective customers written by Walter Davidson. In part it read, "Bill Harley and I and my brothers have ridden motorcycles, built them and lived with them for 21 years."

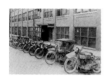

PLATE 066 (1924)
This mid-1920s view shows bikes and sidecars ridden by factory guys lined up along Juneau Avenue outside the shop entrance door. The front office is just around the corner to the right. The building looks very similar today, although the bikes parked outside have changed.

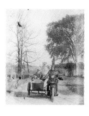

PLATE 067 (1924)
A Halloween sidecar ride in the rolling farmland near Milwaukee is one of life's finer pleasures, as the satisfied expressions of this well-leathered rider and his pumpkin-toting companion show. These were probably factory guys out enjoying an autumn day. The photo originally appeared on the cover of the November 1924 Harley-Davidson *Enthusiast.*

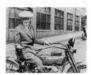

PLATE 068 (1924)
Company president Walter Davidson wore factory-approved attire when he posed for this 1924 photograph, used in company sales literature that year. Walter had been a rider from the earliest days, and in 1908 he won a prestigious endurance run through the Catskill Mountains. At that time the Harley-Davidson was so unknown outside Milwaukee that the *New York Times* incorrectly called Walter's mount the "Howard-Davidson."

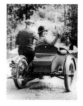

PLATE 069 (1924)
The Wisconsin license plate "2C" indicates this is probably a Harley factory couple on a country jaunt. During these years the Harley-Davidson *Enthusiast* contained suggestive gossip of "Uncle Frank" (Howard E. "Hap" Jameson) and his secretary—the famous "Steno"—who was described as having considerable "sox" appeal. Is that who we see here? Note the solo machine parked on the bridge in this posed photo and above it the interesting caution sign.

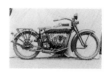

PLATE 070 (1924)
By 1924, the Harley-Davidson motorcycle looked somewhat dated compared to the competition. The angular lines of the "square" fuel and oil tanks, although rounded somewhat over the years, still looked very much like the bikes of the early 1910s. It was time for a change, which came the following year in 1925.

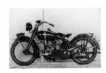

PLATE 071 (1925)
Arthur Constantine has been credited with the 1925 redesign of the Harley-Davidson Big Twin, with its lower frame and seating position and its streamlined tanks. However, the historian who credited Constantine with this work also claimed that he secretly designed a 45-cubic-inch twin while working for Harley and was fired for it. Supposedly, Constantine then took it to Excelsior, who brought it out as the Super X. But that's clearly impossible because the Super X 45 first appeared in 1925, at which time Constantine was definitely known to be working at Harley-Davidson.

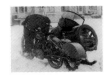

PLATE 072 (1925)
This 1925 Big Twin exhibits one of the more ambitious attempts to make a better winter motorcycle. Using a modified rear frame section, the inventor mounted a chain-driven lugged drum for use in deep snow. Also note the sledlike runners. It is unknown how successful this unique predecessor of the modern snow-mobile was.

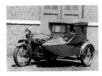

PLATE 073 (1925–26)
Sidecar popularity peaked during the late 1910s and remained strong throughout the 1920s. Around 1918 Harley-Davidson introduced a two-passenger (also called double-wide) sidecar chassis with a 56-inch tread. With the enclosed top seen on this 1925 or 1926 machine, the motorcycle was now suitable for the whole family.

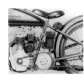

PLATE 074 (1926)
The spring seat-post shown in this cutaway view of a 1926 Model B "Single" went back to 1912, when Harley's "Ful-floteing-Seat" was first introduced. This was one of Bill Harley's most successful inventions and was used on most Harley-Davidson motorcycles for nearly seven decades. The Model B—dubbed the "Eighty Mile Per Gallon" bike—was the inspiration for the 45-cubic-inch side-valve twin of 1929, which in turn developed into the 74-cubic-inch Big Twin of 1930.

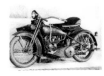

PLATE 075 (1927)
The 74-cubic-inch "Superpowered Twin" first appeared in 1921 as a better sidecar plugger and a faster solo mount. The 1927 model shown here was the zenith for H-D's standard inlet-over-exhaust f-head motor. Better roads and greater rider expectations called for more speed and power than the old pocket-valve could deliver.

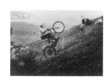

PLATE 076 (CIRCA 1926 TO 1929)
In the 1920s professional hillclimbing surpassed track racing in popularity. To compete, Harley-Davidson offered special 61- and 80-cubic-inch hillclimbing machines. These bikes used the hot "two-cam" racing engine and a "three-bar" reinforced frame. Harley's engineers did considerable experimentation using hillclimb engines as test-beds for new ideas. This work culminated in the overhead-valve, 61-cubic-inch "Knucklehead" twin of 1936.

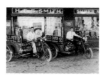

PLATE 077 (LATE 1920s)
Commercial sidecars saw widespread use during the 1920s, when nearly every city of size had delivery services using Harley-Davidson motorcycles. Catchy paint schemes and sometimes unusual sidecar bodies were hallmarks of these vehicles, no longer seen on American streets.

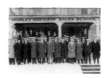

PLATE 078 (LATE 1920s)
Harley-Davidson held its first sales school in 1927 to better educate dealers on proper techniques when making police or other official sales. It also encouraged them to clean up their shops and make them more attractive. The sales school was located in a former residence at 343 38th Street on the south side of the factory. The building no longer exists.

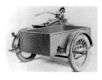

PLATE 079 (LATE 1920s)
Utility sidecars turned the ordinary motorcycle into a three-wheeled pickup truck. Frank "Uke" Ulicki—the Kenosha, Wisconsin, Harley dealer since 1930—remembers moving the entire contents of his business using such a rig. A late 1920s example is shown here.

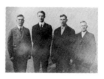

PLATE 080 (MID-LATE 1920s)
Some important men in H-D's engineering department in the late 1920s included, from left, unknown (possibly Charlie Featherly); Alfred Kuehn, Harley's chief designer after 1930 (who according to the late William H. Davidson had strong input on the 1936 61 OHV); Ed Kieckbusch, an electrical expert who became foreman of H-D's experimental department around 1935; and Ed Pfeffer, an H-D employee since 1913 who was later in charge of Harley's drafting room.

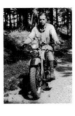

PLATE 081 (1930)
Winter riding was a
serious pursuit that called
for special equipment.
Lap robes and winter
windshields were mounted
on bikes around the
Harley factory as soon
as the weather turned
cool. As company litera-
ture promised, "When
the corn is on the shock,
and the frost is on the
pumpkin, motorcycling
is at its best."

PLATE 082 (1930)
William H. Davidson
(son of co-founder
William A. Davidson
and father of William G.
Davidson) shown at the
time of his 1930 first-place
win in Michigan's famous
Jack Pine Endurance Run.
Davidson said in a 1990
interview that the photo
was actually taken in the
Wauwatosa woods, but
that the motorcycle
and clothing were the
same as he used in the
Jack Pine so the photo
was "authentic in that
respect." This photo also
appeared on a printed
memorial at Davidson's
funeral service in 1992.

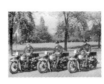

PLATE 083 (1930)
For two days of rough
going through the muck
swamps and sand barrens
of northern Michigan,
the Jack Pine Trophy
consisted of this humble
"cow bell." This led to
endless bovine jokes
about the contest and
its participants. Davidson
was the first non-Michigan
rider to win the presti-
gious event. He rode a
1930 45-cubic-inch side-
valve model.

PLATE 084 (1934)
Harley-Davidson police
radios were introduced in
late 1932. Here we see
them mounted on the rear
luggage carriers of three
1934 Big Twins. This one-
way radio was developed
by Harley's engineers in
collaboration with outside
experts. With the speaker
mounted near the handle-
bar, the motorcycle officer
could instantly receive
instructions from head-
quarters and go directly to
the scene of the crime—
or to the rescue.

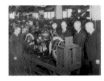

PLATE 085 (LATE 1935)
This photograph, perhaps
the best-loved in Harley
history, shows the four
founders in late 1935 with
a prototype 61 OHV—the
first Knucklehead. Three
decades earlier, these men
had begun an extraordi-
nary journey when they
decided to take the work
out of bicycling. But they
could hardly have imag-
ined the great distance
between their first spindly
razor-strap job and the
fabulous iron horse seen
here. These four men and
their EL model determined
the future course of
American motorcycling.
From left: Arthur
Davidson, Walter
Davidson, William S.
Harley, and William
A. Davidson.

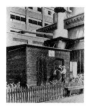

PLATE 086 (1937)

This photo of the original "woodshed" factory dwarfed by the massive Juneau Avenue plant first appeared on the cover of the July 1937 issue of Harley-Davidson's *Enthusiast* magazine. It has been reprinted many times since. But did you know the man watering the flowers is Oscar Greenwaller? According to old-time employee Joseph Borgen, Greenwaller was yard foreman and did guard duty on weekends. The woodshed stood behind the guard shack until the early 1970s, when it was demolished without the knowledge of then-company president William H. Davidson.

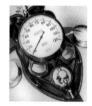

PLATE 087 (1938)

Prototypes of Bill Harley's patented dash assembly were seen on a mock-up of the aborted 65-cubic-inch model "W" of 1931. Its first appearance on a production bike was the 1936 Knucklehead. The 1938 unit shown here came with idiot lights instead of the former "fifty-cent" amp and oil gauges that quickly vibrated to pieces.

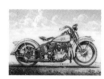

PLATE 088 (1938)

With such nice puffy clouds in the background, don't you just want to hop on this big 80-cubic-inch 1938 ULH and ride away? The previous year, the other models in Harley's lineup were restyled along 61 OHV lines and given the EL's recirculating oil system. In spite of this upgrading, high-octane gas and better roads pushed overhead-valves to the forefront. By 1949 the Big Twin Harley flathead was gone forever, although the flathead itself would still live in the K Model and Servi-Car.

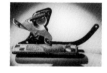

PLATE 089 (1938)

What looks like modern art is actually the clutch and footboard assembly from a 1938 45-cubic-inch side-valve twin. First appearing on Harleys in 1914, footboards have been a fixture on Milwaukee products ever since. The foot clutch was standard on the Big Twin until 1952, but even after a hand clutch was introduced, the traditional Harley foot clutch/hand shift remained a distinct model through 1972.

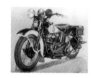

PLATE 090 (1938)

Soon after its introduction in 1936, the 61 OHV became popular with law enforcement agencies due to its high-speed reliability. Here is one of the 1938 California Highway Patrol 61 OHVs, delivered with large output generator, radio (in place of the saddlebags), siren, and special lighting.

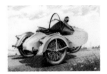

PLATE 091 (1938)

This 1938 sidecar shows the more rounded look that first appeared on 1936 models, a style unchanged until 1969. That year Harley-Davidson switched to a new sidecar body built of fiberglass, which was produced at the former Tomahawk (Wisconsin) boat company that H-D had recently purchased.

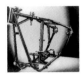

PLATE 092 (1938)

The 1938 Big Twin frame was a stronger version of the original 1936 type used on first-year Knuckleheads. This pattern, used through 1957 with few modifications, was the classic Harley "rigid" or "hardtail" frame. The "straightbar" style shown here was the favorite of custom "chopper" builders of the 1960s and 1970s. Thousands of these frames were "chopped" and their footboard, gas tank, and tool box mounting brackets removed. For this reason original condition frames of this vintage are rare and valuable.

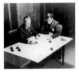

PLATE 093 (1938)

The motorcycle police officer needed special training to operate safely and efficiently. Harley-Davidson offered technical advice and training, and beginning in 1928, began publishing *The Mounted Officer*, a magazine devoted to the police motorcyclist. The magazine is currently being published again.

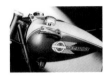

PLATE 094 (1939)

The 1939 two-tone paint scheme was one of Harley's best. It brought the frame-line up through the gas tanks in a smooth, flowing manner. This look was so attractive that Harley-Davidson has brought it back in recent years. The classic "flying wheel" tank decals lasted only from 1936 to 1939. Sixty years later, many consider them among Milwaukee's best tank graphics.

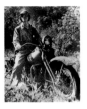

PLATE 095 (1942)

During World War II, the armed forces of several nations sought a combat role for the two-wheeler. The successful blitzkrieg tactics of German motorcycle troops seemed to prove its viability—until partisans learned how to stretch wire across roads. Still, some 88,000 45-cubic-inch WLA model Harleys and variants were built for Allied armies. Here a member of the Armored Force School trains at Fort Knox, Kentucky, where Lieutenant John E. Harley—the youngest son of co-founder William S. Harley—was a motorcycle instructor.

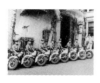

PLATE 096 (WORLD WAR II)
After the Japanese attack on Pearl Harbor in 1941, police and civil defense forces in Hawaii were beefed up in case the enemy returned for a second try. Maybe that's why the Honolulu Police Department was equipped with this group of 1942 Big Twin side-valves, when the bulk of company production was devoted to military 45s.

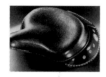

PLATE 097 (1947)
The solo seat is one of Harley-Davidson's most enduring accessories, and it is still listed in H-D's 1999 "Genuine" parts and accessories catalog with its original part number. Two versions are offered: the 1925 "standard solo saddle" and the 1947 "deluxe solo saddle with nostalgic skirt." Keeping them was no mistake. The solo seat is probably the most comfortable motorcycle saddle ever designed. Seen here is the deluxe 1947–54 version.

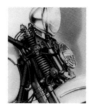

PLATE 098 (1947)
Harley-Davidson tried a number of shock-absorber designs in the 1940s to improve the ride of the spring fork. In 1945, the design shown here (probably on a 1947 model) was introduced. It was offered as standard equipment until the springer was phased out on Big Twins in 1949, but it continued on the Servi-Car until 1958. In 1988, Harley-Davidson reintroduced the old springer on the Softail line and stunned the motorcycling world.

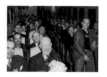

PLATE 099 (1947)
In 1947, Harley-Davidson paid $1.5 million for the former A.O. Smith propellor plant in the Milwaukee suburb of Butler. That November, dealers and factory officials (including company president William H. Davidson at lower left) boarded a special train for a "Secret Destination Run." After an hour's ride through the autumn darkness, the train backed into the covered rail-siding of a brightly lit building. There everyone disembarked at the new factory where a "splendid buffet" awaited them. Also on hand were the new 1948 models, including the first year model of the Panhead powered Big Twin.

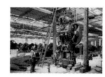

PLATE 100 (LATE 1940s)
Machinery going in at the new Butler plant during the late 1940s included a battery of huge presses. This one was used to stamp out blanks for gas tanks and other sheet-metal parts.

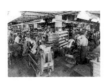

PLATE 102 (1949)
While not the one-person-builds-a-bike operation of the 1920s and earlier, the Harley-Davidson assembly line didn't change much between 1930 and 1950. This 1949 photo shows Hydra Glides being built in batches and moved along on hand-pushed trucks as workers installed their assigned parts. For decades H-D's Big Twin assembly line was on the third floor at Juneau Avenue.

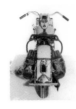

PLATE 103 (1949)
This rear tire view gives one the feel of the substantial yet relatively narrow and nimble 1949 Panhead. Note the massive Hydra Glide fork, clean handlebar, and hand shift lever on the left tank. This bike set the pattern for Harley-Davidson Glide models through to the present day, although rear shocks, bigger tanks, and fiberglass saddlebags have fattened it up over the years. Note also the useless rear bumper, the first sign of the overaccessorized Harleys of later years, often denigrated as "garbage wagons."

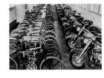

PLATE 104 (1950)
Harley-Davidson started its Archives bike collection around 1915. Even then, examples of their earliest work had to be cobbed together, most notably the 1904 and 1905 models shown here. Later the factory hedged and relabeled the 1904 bike a 1903/1904 model. For H-D's ninety-fifth birthday, the 1904 was dismantled, studied, and then authentically restored to its original racy configuration. The newest bike in this photo is a 1950 Hydra Glide, the inspiration for the current Heritage Softail.

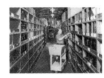

PLATE 105 (1950)
One reason for H-D's success was its high-quality replacement parts. Already in the 1910s, H-D warned riders against using imitations. That message continues to the present day. Here, around 1950, Ralph Reimer fills a dealer order in the big south building at Juneau Avenue, where over five thousand separate bins held parts and accessories.

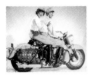

PLATE 101 (1949)
The Hydra Glide telescopic front fork first appeared on the Panhead Big Twin in 1949. Club uniforms of the prewar years were still popular, but were soon branded as "the military look." As a result, the black leather jacket took over in the 1950s. The 1949 Hydra Glide was the only year with black painted lower legs. Although the Hydra Glide was standard equipment in 1949, Big Twins (for both solo and sidecar use) were still available on special order with the spring fork.

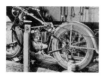

PLATE 106 (1950)
After Hitler lost World War II, several German vehicle designs found their way to other countries. One that surfaced in America was the prewar German DKW, redesigned as the Harley-Davidson Model S. Here the 125cc lightweight is undergoing a prolonged running test in Harley's experimental department. The mechanical throttle automatically changed engine speed, and bumpy road conditions were simulated by moving rollers.

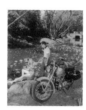

PLATE 107 (1952)
The 45-cubic-inch K model was the perfect bike for taking your sweetheart out on a country jaunt. Its lighter weight and better maneuverability let you park it right on the river-bank. To the surprise of many riders, H-D stuck to the side-by-side valve layout in this new motor, which replaced the old 45. In 1954 the K was enlarged to 55 cubic inches as the KH, and in 1957 it was replaced by the overhead-valve Sportster.

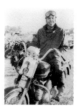

PLATE 108 (1952)
Everyone knows that William G. Davidson—better known as Willie G.—is H-D's vice-president of styling. But did you know that as a teenager he participated in local endurance runs? In 1951, Davidson took top honors at a Waukesha Club event with 994 points. The next October he placed fourth in the Roaring Tigers Club's fall run. These endurance contests were run over dirt roads, water crossings, and with "short cuts" through pastures and gravel pits.

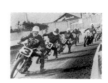

PLATE 109 (1953)
Paul Goldsmith of St. Clair, Michigan, leads the pack in the first turn of the 15 Mile National Championship at Milwaukee in 1953. The Model KR ridden by Goldsmith and others was Harley's racing version of the standard K model side-valve engine. Enjoying a 250cc displacement advantage over British overhead-valve racing engines, the KR was competitive on the flat track until AMA rules were changed in 1968. In its final form the KR developed 60 horsepower, which allowed Cal Rayborn to end the KR's career in a blaze of glory when he won the Daytona 200 in 1969.

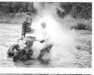

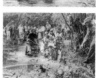

PLATE 110 (1930s)
& PLATE 111 (1954)
The Jack Pine Enduro began in 1926 and grew over the years to become the country's premier endurance contest. After World War II, it was back bigger and badder than ever. Here two entries in the sidecar class slog through river crossings. The first photo shows a 1930s vintage Big Twin stalled in the Rifle River. The other shows "Two Tired," the 1954 sidecar winner, piloted by Stan Capell of Olmstead Falls, Ohio, with passenger Ellis Clement. In 1953 there were 364 Jack Pine entries, but only 89 finishers.

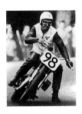

PLATE 112 (1954)

Joe Leonard was the star of the dirt-track circuit in 1954, when he dominated the scene. That year he won eight nationals and took the Grand National Championship. Harley-Davidson's *Enthusiast* magazine was filled with news flashes about Leonard's wins. He took the Grand National Championship again in 1956 and once more in 1957, earning Joe Petrali's old nickname, "Smokey Joe."

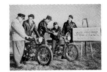

PLATE 113 (MID-1950s)

The postwar two-stroke Harleys introduced a new generation to motorcycles— and black leather jackets. Here Bill Knuth (left) instructs a smiling Elvis look-alike on a 165cc model, while an assistant teaches a younger and more serious student the fine points of the 125. Knuth was the Milwaukee H-D dealer from 1924 to the time of his death in 1959. Beloved by his riders and the Harley factory, Knuth was referred to as "our Bill."

PLATE 114 (1956)

Elvis Presley was twenty-one years old when he recorded "Heartbreak Hotel" and purchased a 1956 KH model from the Memphis Harley dealer. The "King" started out on a lightweight 165, then moved up as his confidence—and finances—improved. Presley and his KH appeared on the cover of the *Enthusiast* in May of 1956. He went on to own several more Harleys, but probably not the number of supposed "Elvis bikes" that have surfaced on the collectors' market in recent years.

PLATE 115 (1958)

Harley-Davidson was somewhat tardy introducing rear springing on the Big Twin. The shock-equipped Duo Glide model wasn't introduced until 1958, although with the spring seat post and telescopic front fork, the previous Hydra Glide model wasn't a bad ride. One roadblock to rear springing had been designing a satisfactory brake for the new swingarm frame. The solution was a hydraulically operated unit that did away with the awkward crossover shaft and long operating rods.

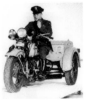

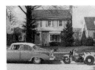

PLATE 116 (1947) & PLATE 117 (1958)

The Servi-Car was among Harley-Davidson's most unique products. It was introduced in 1932 as an auto pick-up vehicle, but law enforcement agencies soon found the three-wheeler useful for traffic control and ticket duty. The Servi-Car was the first Harley with electric start (1964), 12-volt generator (1964), and alternator (1966). It was the last Harley with a spring fork (1957), and when discontinued in 1973, it was the last side-valve engine from Milwaukee.

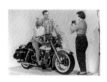

PLATE 118 (1958)

When the Duo Glide was introduced in 1958, the image of the Harley rider had changed once again. The club uniform was fading fast, and the black leather jacket look had become taboo after Brando's movie *The Wild One* alarmed parents and civic reformers. Instead, Harley advertising stressed whitewall tires off the family sedan and well-scrubbed riders enjoying a Sunday picnic. Absent was any safety gear that might have hinted at the motorcycle's dangerous side.

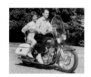

PLATE 119 (1961)

In its early years, a touring role for the Sportster was emphasized more than it is now. This 1961 XLH is equipped with a 4.5 gallon gas tank and the optional Highway Cruiser Group, consisting of the Sportster Buddy Seat, plastic saddlebags, and solo windshield.

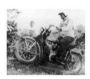

PLATE 120 (1961)

In 1961, the XLCH Sportster was advertised as an "on-the-road" and "off-the-road" dual-purpose machine. Sporting a gas tank lifted from the 125 lightweight, magneto ignition, TT pipes, valance-free front fender, tin primary cover, "futuristic" headlight nacelle, and knobby tires, the CH was a completely new beast. This was a "hot and hustling" machine for riders who liked to take a big bike into the rough stuff.

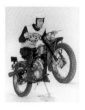

PLATE 121 (1962)

With a name that was as dual purpose as the bike, the 1962 Scat was a road legal, 175cc package based on the 165cc single, which in turn was an offshoot of the original 1948 125cc model. While Harley fans typically call all these small two-strokes Hummers (the gas tank is similar to the Sportster's), the Hummer was a distinct model sold between 1955 and 1959. The Milwaukee-built two-strokes were phased out in the 1960s in favor of the Italian-built lightweights.

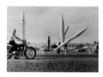

PLATE 122 (1963 OR 1964)

The Sportster XLCH was the perfect bike to tool around the desert with if you were an off-duty military man in the early 1960s. This looks like White Sands Missile Range in New Mexico, and it fits perfectly with Harley's Space Age advertising, which began around 1960. Sportsters were billed as having a "jet silhouette" for a low-in-the-saddle "rock and sock" look. Coolsville daddy-o!

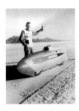

PLATE 123 (1965)

George Roeder, the "Yankee farmer" from Monroeville, Ohio, began as a dirt-track racer in the 1950s. In 1963, he finished just one point behind Dick Mann for the Grand National Championship. Maybe that's why Roeder was chosen to pilot the 250cc Sprint streamliner for a record-breaking speed run in 1965. That October, Roeder broke Roger Reiman's earlier record when he reached 176.817 mph on the Bonneville Salt flats.

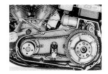

PLATE 124 (1965)

Adapting electric-start to the Big Twin was a challenge for Harley-Davidson's engineering department. Maybe that's why the Servi-Car came out with an electric starter in 1964, a year before the Electra Glide was unveiled. With its primary cover removed, the starter motor is seen above the clutch hub along with the externally mounted starter solenoid. Also note the new "brake shoe" – style chain tensioner. Previous Big Twins had adjusted the front chain by sliding the transmission back. The 1965 Electra Glide is unique in being the only electric-start Panhead.

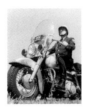

PLATE 125 (1965)

The 1965 Electra Glide was the culmination of sixty years of development of the Harley-Davidson motorcycle. What began in 1903 as an improved motor-bicycle had become by 1965 the king of the highway. But much lay ahead. The coming decades would see explosive changes, new challenges, and exciting innovations from what had become an American institution: the Harley-Davidson Motor Company.

THIS BOOK *was printed in two colors on a sheetfed printing press using PMS inks on 157 gsm Japanese matte art paper. The case has been covered in T-Saifu linen cloth. The metal plate adhered to the debossed area on the front case of the book is made of brushed aluminum that has been silkscreened in two colors. The fonts used in the book are Goudy Old Style, Windsor, and Akzidenz Grotesk.*